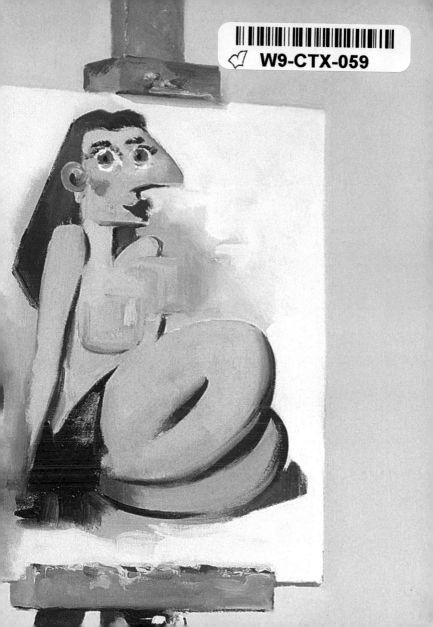

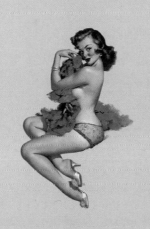

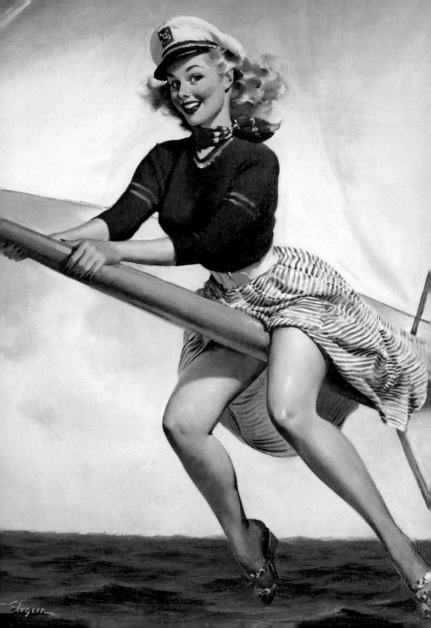

DIAN HANSON

THE LITTLE BOOK OF PIN-UP
ELVGREN

THE KING

TASCHEN

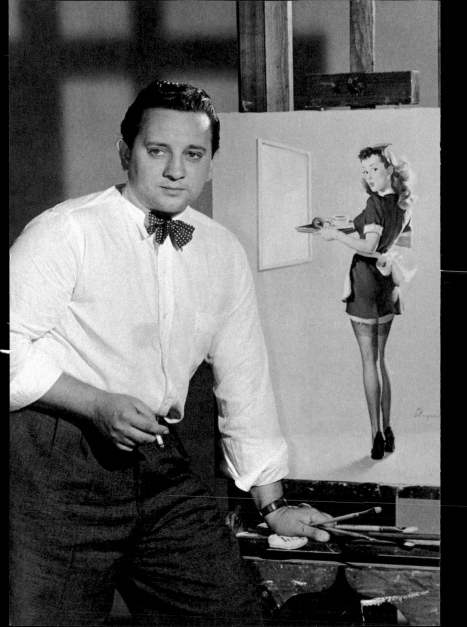

ALL HAIL THE KING

BY DIAN HANSON

> *His genius was in maintaining each model's individuality while perfecting her face and figure, yet somehow keeping her attainable.*

In the 1930s, it was George Petty. In the '40s, Alberto Vargas. But for the past 60 years, pin-up has been all about Gil Elvgren, the undisputed king of the craft. His enduring popularity is a mix of superior talent and appealing subject: Sparkling eyes, warm smiles and hourglass figures never go out of fashion, and his girls never look dated.

Maybe it's because Elvgren's personal esthetic was ahead of his time. He famously described the perfect pin-up model as having the face of a 15-year-old on a 20-year-old's body—not very PC, but a pretty good descriptor of the average man's fantasy. His long-time model Myrna Hansen, who posed for him from the age of 13 (well-chaperoned by her mother), said he even glued younger faces on more mature bodies to create reference photos for his paintings. He denied finding young faces sexier, rather that their wholesome innocence tempered the sensuality of the bodies he painted, bodies perfectly proportioned yet still human, with flesh so realistically yielding that a man knew just how it would feel in his hands.

You'd think Elvgren painted from live models to get that kind of realism, but he worked exclusively from photographs, meticulously posed and personally snapped. Myrna said he was a complete gentleman in photo sessions, as evidenced by his posing wand, the long wooden stick he used to gently prod his models

into position, so he'd never have to touch them. And while he did take up with a model in mid-life, that was only after his wife's death. Mostly, Elvgren was focused on his art, producing and perfecting it, from age 19 until his end, at 65.

His beginning was on March 15, 1914, in St. Paul, Minnesota, home to the Brown & Bigelow calendar company that would employ him for 28 years. His parents owned a paint and wallpaper store; his childhood was pleasant, middle class and unremarkable. In high school he planned to become an architect, but a year into his studies at the University of Minnesota he realized he wanted to be a painter. With his life purpose clear, he impetuously married his high school girlfriend and they moved to Chicago so he could attend the American Academy of Art. His teachers later remembered him as a highly motivated and determined student who took day and night classes, packing three years of study into two.

He returned to St. Paul in 1936, opened a studio, and immediately got catalog cover work. More significant to his future, he received a commission from Brown & Bigelow to paint two calendar illustrations of the Dionne quintuplets, five identical girls born to a French Canadian family in 1934. Elvgren would have happily signed with B&B right then, but no contract was offered, so in 1937 he signed a deal with their competitor, the Louis F. Dow Company, to paint pin-up girls.

The Dow years taught Elvgren the theory of pin-up, but those early paintings look crude compared to his later work for Brown & Bigelow. He needed a mentor to refine his style, and he found him in Haddon Sundblom of the Stevens/Gross Studio upon his return to Chicago in 1940.

Sundblom is best remembered for his Coca-Cola campaigns, particularly for creating the Coca-Cola Santa Claus, which became the accepted image of Father Christmas worldwide. In the 1940s he also painted some beautiful pin-up girls for Cashmere Bouquet soap, and these girls became the inspiration

Page 8: *Bear Facts*, 1962.

Page 9: Gil Elvgren, far right, sketches the winner of a St. Paul, Minnesota, beauty pageant at the Brown & Bigelow offices in 1948.

for Elvgren's own pin-ups. It wasn't just their sweet faces and lush figures that attracted Elvgren; Sundblom had a distinctive way with oil paint, called the "mayonnaise school" by detractors, for its thick, swirling application on canvas. All the pin-up artists who worked at Stevens/Gross, including Al Buell and Joyce Ballantyne, picked up the style, but none applied the mayo as deftly as Elvgren. He soon had his own Coke commissions and the familiar Elvgren pin-up style took form.

Meanwhile, he was still supplying pin-ups to Dow, which, with the start of World War II, aggressively marketed his prints to servicemen, increasing his name recognition. With two children and a third on the way he was exempt from the draft, and he got all the work from those who were drafted. Life was good, but about to get much better.

In 1944 Brown & Bigelow offered Elvgren an exclusive contract to paint 24 pin-ups a year for $24,000. At that time *Esquire* magazine was paying pin-up star Alberto Vargas just $3,600 a year to paint twice as many pin-ups, and allowing no outside commissions, while Elvgren's contract applied only to pin-ups, leaving him free to continue taking advertising work through Stevens/Gross. He was delighted to take the offer, broke the news to Louis F. Dow, and began work at B&B in 1945. Dow responded by hiring young Vaughan Bass to paint over Elvgren's originals, all retained by Dow, changing all but the faces, so the company could release them as new works. Did Elvgren protest? Probably not, since he was busy creating the first of his legendary paintings for Brown & Bigelow calendars. He began by adopting a larger canvas size, 30 x 24 inches, which would remain his standard to the end of his career, and then applied everything he'd learned from Sundblom. The first calendar was *Back in the Saddle Again*, done in 1944, before his official hiring, for a 1946 release. All the paintings done in 1945 were issued in 1947.

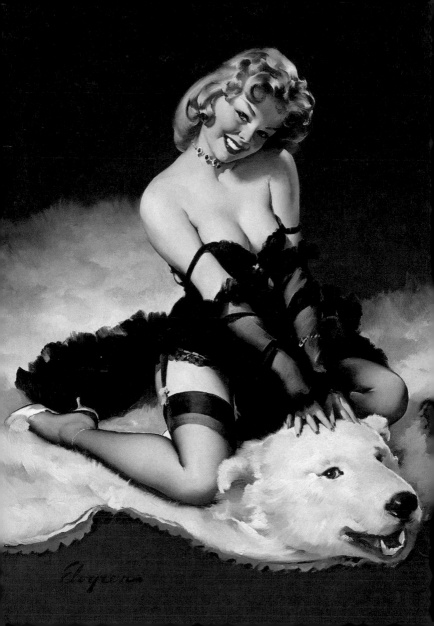

By his second year at B&B Elvgren had his style down. Those 1945 pin-ups were a little bland, but by the time he painted *Gay Nymph*, his first nude, in '46, everything we love was in place: luminous skin, soft flesh, radiant smile and inviting warmth. Still, Elvgren continued to improve through his 28 years with Brown & Bigelow. Every year was a new peak, with no decline as he moved through his 40s and 50s. His girls became ever more believable, with increasingly expressive faces and more voluptuous figures. These faces changed with his models, of course, Myrna Hanson being prominent in the late '40s and early '50s, while Marjorie Shuttleworth, the companion of his last 15 years, is recognizable in his late-'60s paintings. In between he used many others—some great, some less so—an even mix of blondes and brunettes, with the occasional redhead. His genius was in maintaining each model's individuality while perfecting her face and figure, yet somehow keeping her attainable. It was such a successful combination that Brown & Bigelow raised his salary to $75,000 a year in 1950, making him a very wealthy man.

He used the raise to move his wife and three children to a cushy home in Winnetka, outside Chicago. In 1956 he upgraded to a better home in Siesta Key, Florida, near his old friend Al Buell. He bought a boat, cut back on his punishing schedule, and enjoyed more time with his family. Then in 1966 his

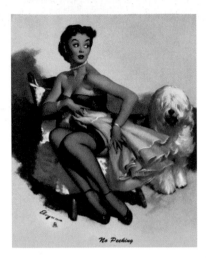

Left: No Peeking, 1955.

Opposite: Did You Recognize Me by My Voice?, 1948.

Pages 12-13: Commission for Simoniz car polish, circa 1960. This and a second Simoniz painting were found in an abandoned house by a lucky construction worker and brought a combined $107,550 at Heritage Auctions.

wife, Janet, died of cancer. Elvgren was devastated, and sought relief in work, but he'd jettisoned most of his advertising clients to concentrate on pin-up, and pin-up's popularity was dwindling. Charlie Ward, Brown & Bigelow's exuberant president, had died in 1959, and the company was sold shortly thereafter. The new owners contracted for fewer pin-ups each year, and paid less for them. In 1970 the company was resold, and in '72 B&B stopped buying pin-ups altogether. Elvgren, 58 years old, was essentially retired. Marjorie was a comfort, but Elvgren would not marry again, taking real pleasure only in painting. He continued producing pin-ups right to the end, leaving an unfinished canvas when he died from cancer in 1980, at age 65. His wealth was mostly gone, but his talent was as fresh as ever, and even in her unfinished state that final pin-up girl had the old Elvgren twinkle in her eye.

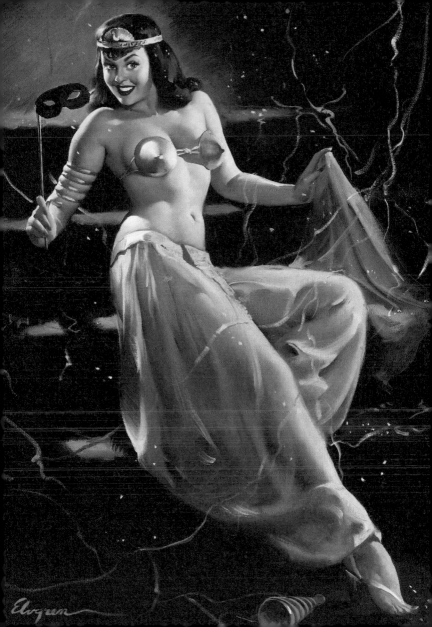

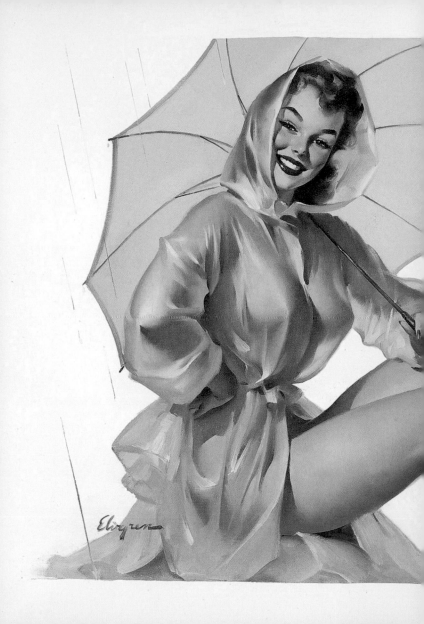

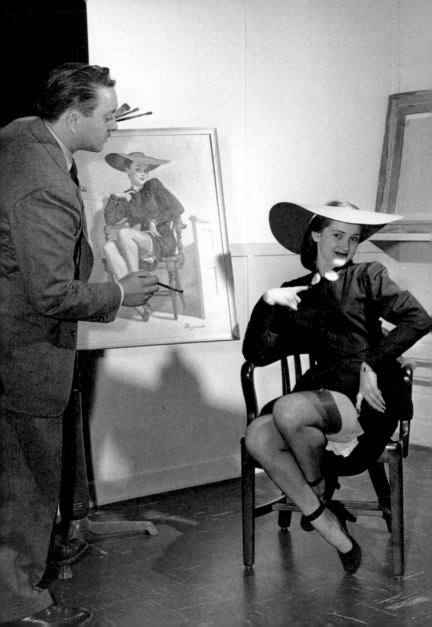

HOCH LEBE DER KÖNIG

VON DIAN HANSON

Sein Genie zeichnete sich dadurch aus, dass er das Individuelle jedes Models wahrte, während er Gesicht und Körper perfektionierte und es schaffte, die Mädchen weiterhin nahbar wirken zu lassen.

In den 1930er-Jahren war es George Petty. In den 1940ern Alberto Vargas. Doch in den letzten 60 Jahren drehte sich die ganze Pin-up-Welt um Gil Elvgren, den unangefochtenen König der Zunft. Seine anhaltende Popularität verdankt er einer Mischung aus überlegenen Fähigkeiten und den besonderen Reizen der Darstellungen seiner Modelle: Funkelnde Augen, ein warmes Lächeln und sanduhrförmige Figuren kommen nie aus der Mode, und seine Mädchen wirken nie veraltet. Vielleicht weil Elvgrens persönliche ästhetische Vorstellungen seiner Zeit weit voraus waren. Bekanntlich beschrieb er das perfekte Pin-up-Model als ein Mädchen mit dem Gesicht einer Fünfzehnjährigen auf dem Körper einer Zwanzigjährigen – politisch korrekt ist das nicht unbedingt, doch es umreißt die Fantasien des Durchschnittsmannes ziemlich genau. Sein langjähriges Model Myrna Hansen, die seit ihrem 13. Lebensjahr für ihn posierte (natürlich brav von ihrer Mutter begleitet), erzählte, er habe sogar jüngere Gesichter auf reifere Körper geklebt, um sich so Fotovorlagen für seine Malereien zu basteln. Er bestritt, jüngere Gesichter sexyer zu finden, vielmehr mildere ihre gesunde Unschuld die Sinnlichkeit der Leiber, die er male. Es waren perfekt proportionierte Körper mit so realistisch weich wirkenden Hautpartien, dass ein Mann schlicht erahnte, wie sie sich unter seiner Hand anfühlen würden. Man könnte meinen, Elvgren habe, um diese Art realistischer

Darstellung schaffen zu können, nach lebenden Modellen gemalt, doch er arbeitete ausschließlich nach persönlich aufgenommenen Fotografien sorgfältig in Pose gesetzter Models. Myrna berichtete, er habe sich während der Fotosessions wie ein vollendeter Gentleman verhalten. Sein Posierstock, den er benutzte, um seine Models mit behutsamem Schubs in Position zu bringen, sei der Beweis. Auf diese Weise musste er sie nie berühren. Erst nachdem seine Frau gestorben war, begann er schließlich, mit einem Model mittleren Alters zu arbeiten. Elvgren konzentrierte sich weitestgehend auf seine Kunst, die er zwischen seinem 19. Lebensjahr und seinem Tod mit 65 Jahren schuf und perfektionierte.

Am 15. März 1914 kam er in St. Paul, Minnesota, zur Welt, dem Sitz des Kalenderverlags Brown & Bigelow, der ihn für 28 Jahre beschäftigen sollte. Seine Eltern besaßen einen Laden für Farben und Tapeten; in seiner Mittelklassefamilie durchlebte er eine unbeschwerte und unauffällige Kindheit. Noch auf der Highschool hatte er vor, Architekt zu werden, doch nach einem Jahr Studium an der Universität von Minnesota stellte er fest, dass er lieber Maler werden wollte. Mit diesem klar abgesteckten Lebensziel vor Augen heiratete er seine Highschool-Freundin. Dann zog das Paar nach Chicago, damit er die American Academy of Art besuchen konnte. Seine Lehrer erinnerten ihn später als einen hoch motivierten Studenten, der am Tage wie am Abend Unterricht nahm und auf diese Weise drei Studienjahre in nur zwei Jahren absolvierte.

1936 kehrte er nach St. Paul zurück, eröffnete ein Studio und erhielt umgehend den Zuschlag zur Gestaltung von Katalog-Titelseiten. Bedeutsamer für seine Zukunft war ein Auftrag von Brown & Bigelow, zwei Kalenderbilder der Dionne-Fünflinge zu malen, fünf identischen Mädchen, die 1934 in eine französisch-kanadische Familie geboren worden waren. Zu jenem Zeitpunkt hätte Elvgren gerne einen Vertrag mit B & B abgeschlossen, doch wurde ihm keiner angeboten. Also unterschrieb er 1937 eine Vereinbarung mit

dem Konkurrenten, der Louis F. Dow Company, Pin-up-Mädchen zu malen. In den Jahren für Dow eignete sich Elvgren vor allem theoretische Kenntnisse zur Pin-up-Malerei an, doch die Bilder jener frühen Zeit wirken im Vergleich zu seinen späteren Werken für Brown & Bigelow eher derb. Er brauchte einen Mentor, um seinen Stil zu verfeinern, und den fand er bei seiner Rückkehr nach Chicago 1940 in Haddon Sundblom vom Stevens/Gross-Studio.

Sundbloms bekannteste Arbeiten entstanden für seine *Coca-Cola*-Werbe-kampagne, berühmt ist insbesondere der *Coca-Cola*-Nikolaus, der zu einem weltweit akzeptierten Bildnis des Weihnachtsmanns wurde. In den 1940er-Jahren malte er für *Cashmere-Bouquet*-Seifen auch ein paar wunderschöne Pin-ups, und diese Mädchen inspirierten Elvgrens eigene Pin-ups. Nicht nur ihre süßen Gesichter und üppigen Figuren faszinierten Elvgren; Sundblom pflegte auch eine besondere Art und Weise im Umgang mit Ölfarben, die er mit wirbelndem Strich auf die Leinwand setzte – „Mayonnaise-Stil" nannten es seine Gegner. Alle Pin-up-Künstler, die bei Stevens/Gross arbeiteten, auch Al Buell und Joyce Ballantyne, griffen diesen Stil auf, aber keiner ging so geschickt mit der „Mayo" um wie Elvgren. Bald schon erhielt er seine eigenen Cola-Aufträge, der vertraute Elvgren-Pin-up-Stil nahm Formen an.

Unterdessen lieferte er weiterhin Pin-ups an Dow. Mit Ausbruch des Zweiten Weltkriegs vermarktete der Verlag Drucke von Elvgrens Bildern offensiv an Soldaten und steigerte so den Bekanntheitsgrad des Künstlers. Mit zwei Kindern und einem dritten unterwegs war Elvgren vom Wehrdienst befreit, musste jedoch auch die Arbeit all jener übernehmen, die eingezogen worden waren. 1944 boten Brown & Bigelow Elvgren einen exklusiven Vertrag für 24 Pin-ups pro Jahr und ein Honorar von 24.000 Dollar an. Zu jener Zeit zahlte der *Esquire* seinem Pin-up-Star Alberto Vargas gerade mal 3.600 Dollar pro Jahr, zudem musste der Künstler dafür doppelt so viele Pin-ups malen und durfte keine weiteren Aufträge

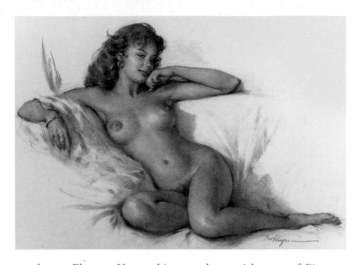

annehmen. Elvgrens Vertrag hingegen bezog sich nur auf Pin-ups, was ihm freie Hand ließ, über Stevens/Gross zusätzlich Werbeaufträge zu erfüllen. Entzückt nahm er das Angebot an, verkündete die Nachricht Louis F. Dow und nahm 1945 seine Arbeit für B & B auf. Dow reagierte, indem er den jungen Vaughan Bass beauftragte, Elvgrens Originale, die Dow alle einbehalten hatte, zu übermalen. Außer den Gesichtern sollte Bass alles verändern, und so konnte der Verlag die Bilder als neue Werke veröffentlichen. Ob Elvgren dagegen protestierte? Wahrscheinlich nicht, denn er war damit beschäftigt, das erste seiner legendären Bilder für Brown-&-Bigelow-Kalender zu malen. Er begann, ein größeres Leinwandformat zu benutzen (76,2 x 60,96 cm) – bis zum Ende seiner Karriere sein Standardformat –, und setzte dann alles um, was er von Sundblom gelernt hatte. Der erste Kalender war *Back in the Saddle Again*, mit Bildern, die er noch 1944, vor seinem offiziellen Engagement, für eine Veröffentlichung 1946 geschaffen hatte. In seinem zweiten Jahr bei B & B hatte Elvgren seinen Stil gefunden. Jene 1945 gemalten Pin-ups waren ein wenig fade, doch als er dann, 1946, *Gay Nymph* schuf, sein erstes Aktbild, war alles da, was wir lieben: die leuchtende Haut, die weichen Körper, das strahlende Lächeln und die einladende Wärme. Dennoch verfeinerte Elvgren im Laufe der 28 Jahre bei Brown & Bigelow weiterhin seine Technik. Jahr für Jahr lieferte er neue Höhepunkte seines Schaffens und ließ über

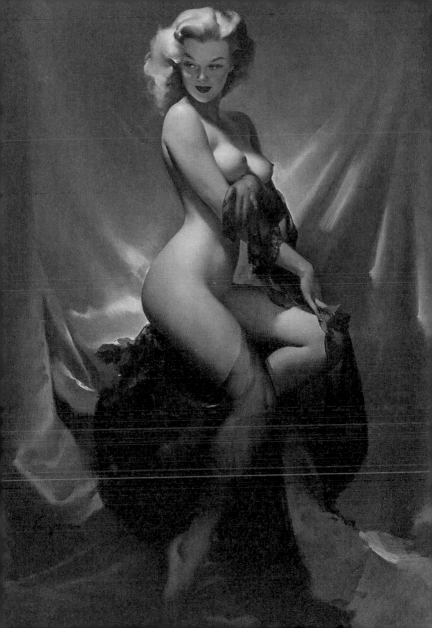

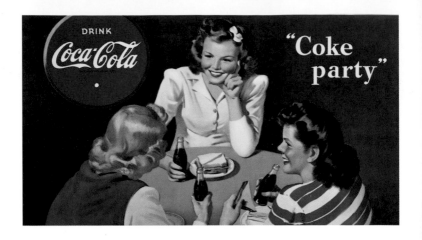

die 1940er- und 1950er-Jahre nie nach. Seine Mädchen wirkten immer glaub-
würdiger, ihre Gesichter wurden ausdrucksstärker und ihre Körper verlockender.
Die Gesichter wechselten natürlich mit den Models. In den späten 1940er- und
frühen 1950er-Jahren war Myrna Hanson prominent, während Marjorie Shuttle-
worth, die Gefährtin seiner letzten 15 Jahre, in seinen Gemälden der späten
1960er-Jahre erkennbar ist. Dazwischen nahm er sich viele andere vor – manche
waren großartig, andere weniger –, eine ausgewogene Mischung aus Blondinen
und Brünetten, gelegentlich auch eine Rothaarige. Sein Genie zeichnete sich
dadurch aus, dass er das Individuelle jedes Models wahrte, während er Gesicht
und Körper perfektionierte und es doch gleichzeitig schaffte, die Mädchen wei-
terhin nahbar wirken zu lassen. Diese Mischung war so erfolgreich, dass Brown
& Bigelow 1950 sein Gehalt auf 75.000 Dollar erhöhte und ihn damit zu einem
sehr reichen Mann machte. Diesen Wohlstand nutzte er, um seiner Frau und
den drei Kindern ein gemütliches Heim in Winnetka, außerhalb von Chicago,
einzurichten. 1956 ging er einen Schritt weiter und bot ihnen ein noch besseres
Zuhause in Siesta Key, Florida, in der Nähe seines alten Freundes Al Buell. Er
kaufte ein Boot, schraubte seine strapaziösen Zeitpläne zurück und genoss mehr
Zeit mit seiner Familie. Dann, 1966, starb seine Frau Janet an Krebs. Elvgren
war am Boden zerstört und suchte Trost in der Arbeit, doch er hatte die meisten

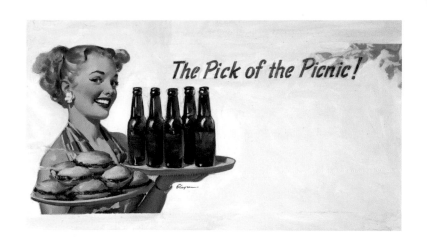

seiner Werbekunden fallen gelassen, um sich auf Pin-ups zu konzentrieren, und die Popularität von Pin-ups war im Schwinden. Charlie Ward, der quirlige Boss von Brown & Bigelow, war 1959 gestorben, kurz danach war das Unternehmen verkauft worden. Die neuen Eigentümer schlossen Verträge über eine geringere Zahl von Pin-ups ab und zahlten weniger dafür. 1970 wurde die Firma erneut verkauft, bis B & B 1972 den Ankauf von Pin-ups generell einstellte. Elvgren, 58 Jahre alt, war nun im Grunde genommen im Ruhestand. Marjorie war sein Lichtblick, doch Elvgren heiratete nicht mehr und genoss wahre Freuden nur noch beim Malen. Bis zu seinem Lebensende malte er Pin-ups, und als er 1980, im Alter von 65 Jahren, an Krebs starb, hinterließ er eine unvollendete Leinwand. Sein Wohlstand war fast ganz dahingeschmolzen, doch sein Talent zeigte sich so frisch wie eh und je – jenes letzte Pin-up-Girl hatte selbst im unvollendeten Zustand das typische Elvgren'sche Funkeln in den Augen.

Opposite: Gil Elvgren illustration on a large Coca-Cola advertising poster, circa 1950, when "Coke party" meant something entirely different.

Above: The Pick of the Picnic, circa 1950, for a Schmidt beer advertisement.

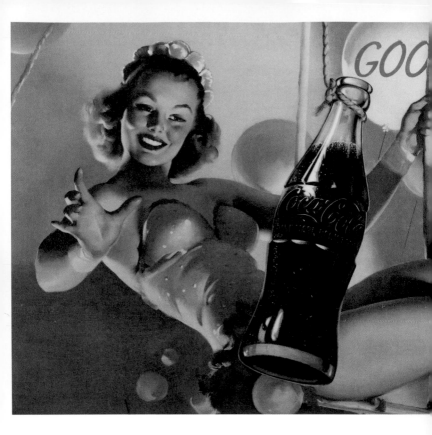

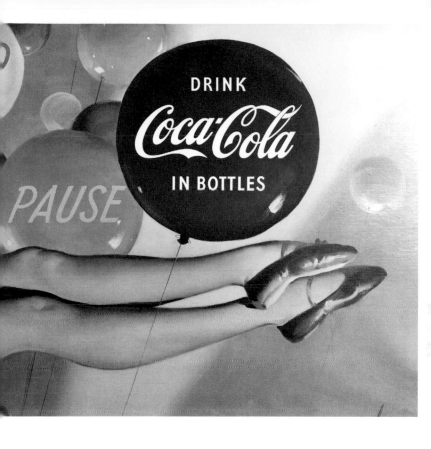

Above: This was Gil Elvgren's most impressive advertising commission for Coca-Cola. The oil on canvas was reproduced as a massive sign for display in soda fountains, mounted in an accompanying Coke-themed frame. Date of creation of the painting is unknown, but the sign is dated 1959. Coca-Cola issued a second version of the sign with the figure and large red balloon silhouetted and the background removed.

VIVE LE ROI !

DE DIAN HANSON

> *Il avait le génie de préserver l'indivi-*
> *dualité de chaque modèle tout en peaufi-*
> *nant son corps et son visage : elle restait*
> *toujours accessible.*

Dans les années 1930, c'était George Petty. Dans les années 1940, Alberto Vargas. Mais depuis soixante ans, le maître incontesté de l'art de la pin-up s'appelle Gillette Elvgren, qui jouit d'une popularité apparemment inoxydable. Deux raisons à cela : un talent exceptionnel et la nature toujours aussi séduisante de son domaine de prédilection. Regards pétillants, sourires enjôleurs et tailles de guêpe restent plus que jamais de saison, aussi ses filles continuent-elles d'échapper à l'obsolescence.

Sans doute l'esthétique personnelle d'Elvgren était-elle en avance sur son temps. On connaît sa fameuse description du parfait modèle de pin-up : le visage d'une fille de 15 ans sur un corps de 20 ans – pas très politiquement correct, certes, mais assez fidèle au fantasme masculin moyen. Myrna Hansen, qui commença à poser pour lui à 13 ans (chaperonnée par sa maman) et fut longtemps son modèle favori, racontait qu'il collait parfois de jeunes visages sur des plastiques plus matures pour fabriquer les photographies qui inspiraient ses illustrations. Non qu'il jugeât plus sexy les visages juvéniles, au contraire, disait-il, leur saine innocence tempérait la sensualité des corps qu'il dessinait : des corps parfaitement proportionnés et d'une humanité néanmoins préservée, grâce à un réalisme qui envoyait à leurs admirateurs un message plus que sensoriel, quasi charnel. Pour parvenir à un tel résultat, on aurait pourtant imaginé qu'Elvgren dessinait à

partir de modèles vivants, or il travaillait bien exclusivement à partir de photos, prises par ses soins lors de méticuleuses séances. Myrna raconta qu'il s'y comportait en parfait gentleman, comme l'atteste la longue baguette en bois qu'il utilisait pour corriger délicatement la posture de ses modèles, afin de n'être jamais contraint de les toucher. Et s'il finit par se lier avec un modèle aux alentours de la cinquantaine, ce ne fut qu'après la mort de sa femme. De 19 à 65 ans, Elvgren resta essentiellement concentré sur son art, sur les meilleurs moyens de le produire et de l'améliorer.

Il était né le 15 mars 1914 à Saint Paul, dans le Minnesota, où siégeait l'entreprise de calendriers Brown & Bigelow, qui l'emploiera pendant vingt-huit ans. Ses parents possédaient une boutique de peinture et de papiers peints ; il eut une enfance agréable et assez convenue, de classe moyenne. Lycéen, il voulait devenir architecte, mais après un an d'études à l'université du Minnesota, il prit conscience de son désir d'être peintre. Le but de sa vie étant ainsi clairement fixé, il épousa fougueusement sa petite amie de l'époque du lycée, avec laquelle il partit habiter Chicago pour y suivre les cours de l'American Academy of Art. Ses professeurs se souviendront de lui comme d'un étudiant extrêmement motivé et déterminé qui ajoutait les cours du soir à son programme normal afin de faire en deux ans l'équivalent de trois années d'études.

Il retourna à Saint Paul en 1936, ouvrit un atelier et se vit immédiatement confier la réalisation de couvertures de catalogues. Plus déterminant encore : la société Brown & Bigelow lui commanda deux illustrations pour un calendrier dédié aux quintuplées Dionne, cinq petites Québécoises nées en 1934. Elvgren aurait alors été ravi de s'engager à plein temps chez B&B, mais comme on ne lui proposait pas de contrat, il signa en 1937 chez le concurrent, Louis F. Dow, qui lui offrait de dessiner des pin-up. Ses années chez Dow apprendront donc à Elvgren la théorie de cet art singulier, mais ses premières peintures semblent un

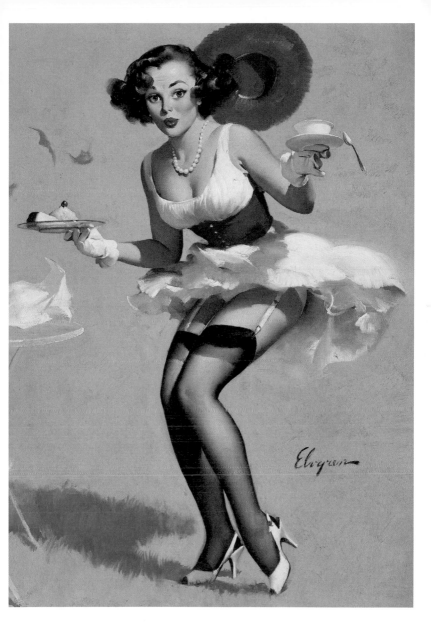

peu rudimentaires quand on les compare à ses travaux ultérieurs pour Brown & Bigelow. En fait, il avait besoin d'un mentor qui l'aide à affiner son style, et il le trouva en 1940, à son retour à Chicago, en la personne de Haddon Sundblom, du studio Stevens/Gross.

On connaît surtout Sundblom pour ses campagnes Coca-Cola, notamment pour la création du personnage de «Coca-Cola Santa Claus» qui engendrera dans le monde entier l'image communément admise du Père Noël. Dans les années 1940, il dessina aussi pour les savons Cashmere Bouquet de ravissantes pin-up qui inspireront incontestablement Elvgren. Ce qu'il aimait chez elles ne se limitait pas à leur mignon minois ou à leurs courbes étourdissantes : les huiles sur toile de Sundblom procédaient en effet d'une technique particulière que ses détracteurs appelaient «l'école mayonnaise», pour l'épaisseur et l'onctuosité de son coup de pinceau. Mais le fait est que tous les dessinateurs de pin-up qui travaillèrent chez Stevens/Gross, dont Al Buell et Joyce Ballantyne, reprirent le style à leur compte. Aucun, toutefois, ne réussissait sa «mayo» avec autant de dextérité qu'Elvgren, qui ne tarda pas à se voir lui aussi confier des commandes Coca Cola. Le style pin-up désormais familier de Gil Elvgren pouvait prendre forme.

Dans le même temps, il livrait toujours des pin-up à Dow qui les écoulait à tour de bras auprès des troupes mobilisées par le début de la Seconde Guerre mondiale, une promotion qui contribua à la renommée de l'artiste. Avec déjà deux enfants et un troisième en route, il échappa à l'uniforme et récupéra tout le travail de ses collègues moins heureux. La vie d'Elvgren, fort bien partie, allait continuer à lui sourire.

En 1944, Brown & Bigelow lui proposèrent un contrat d'exclusivité pour peindre vingt-quatre pin-up par an contre la somme de 24 000 dollars. À cette époque, le magazine *Esquire* ne donnait à la star du métier, Alberto Vargas, pas plus de 3 600 dollars annuels pour dessiner deux fois plus de pin-up, tout en lui

interdisant toute collaboration extérieure… Le contrat d'Elvgren, lui, ne s'appliquait qu'aux pin-up, ce qui le laissait libre d'accepter les travaux publicitaires négociés par Stevens/Gross. Enchanté de la proposition, il démarra chez B&B en 1945, après en avoir bien entendu averti Louis F. Dow. Celui-ci réagit en recrutant le jeune Vaughan Bass, chargé de repeindre les originaux d'Elvgren que Dow avait conservés. En changeant tout sauf les visages, l'entreprise pouvait les publier comme autant d'œuvres inédites. Elvgren protesta-t-il ? Probablement pas, car il avait assez à faire avec la création de la première de ses illustrations légendaires pour les calendriers Brown & Bigelow. Il commença par adopter une taille de toile plus grande, 76 x 61 cm, qui resta sa norme jusqu'à la fin de sa carrière. Il appliqua ensuite toutes les leçons apprises auprès de Sundblom. Le premier calendrier s'appelait *Back in the Saddle Again* (Retour en selle), réalisé en 1944 – c'est-à-dire avant son engagement officiel –, pour une parution prévue en 1946. Toutes les illustrations réalisées en 1945 furent publiées en 1947.

Chez B&B, il ne fallut pas deux ans à Elvgren pour maîtriser son style comme un vieux routier. Ses pin-up de 1945 étaient encore un peu fades, mais lorsqu'il peignit *Gay Nymph*, son premier nu, en 1946, tout ce qu'on aime chez lui était en place : texture de peau lumineuse, tendreté de la chair, sourire radieux et chaleur engageante… Elvgren n'en continua pas moins de progresser tout au long de ses vingt-huit ans chez Brown & Bigelow. Chaque année correspondit à un nouveau sommet que le passage de la quarantaine puis de la cinquantaine n'altéra en rien. Ses girls n'avaient jamais été aussi crédibles, leurs traits aussi expressifs et leurs silhouettes aussi voluptueuses. Bien sûr, les visages évoluaient en fonction des modèles ; Myrna Hanson fut l'égérie de la fin des années 1940 et du début des fifties, alors que Marjorie Shuttleworth, la compagne des quinze dernières années, est reconnaissable dans les travaux datés de la fin des sixties. Il fit entre-temps appel à nombre d'autres filles, certaines géniales, d'autres moins,

brunes et blondes à part égale, occasionnellement rejointes par une rousse. Il avait le génie de préserver l'individualité de chaque modèle tout en peaufinant son corps et son visage : elle restait toujours accessible. L'alchimie était si réussie qu'en 1950, Brown & Bigelow augmenta son salaire à 75 000 dollars annuels, faisant d'Elvgren un homme très riche.

Il profita de l'augmentation pour faire déménager sa femme et ses trois enfants dans une maison tranquille à Winnetka, en dehors de Chicago. En 1956, ils acquirent une propriété encore plus plaisante à Siesta Key, en Floride, à proximité de son vieux copain Al Buell. Il acheta un bateau, réduisit son planning astreignant et put ainsi consacrer plus de temps à sa famille. Mais Janet, son épouse, fut emportée par un cancer en 1966. Ravagé par le chagrin, Gil chercha l'apaisement dans le travail. Or il avait abandonné la plupart de ses clients publicitaires pour se concentrer sur les pin-up, et à cette époque le genre battait de l'aile. Charlie Ward, l'exubérant président de Brown & Bigelow, était mort en 1959, et l'entreprise avait été vendue peu après. Les nouveaux propriétaires diminuèrent chaque année leurs commandes de pin-up, payées de moins en moins chères. L'entreprise fut de nouveau cédée en 1970 et renonça complètement aux pin-up deux ans plus tard. Elvgren, à 58 ans, se retrouvait pratiquement à la retraite. Marjorie lui apportait un réconfort, mais il ne se remaria pas. Seule l'illustration lui apportait un véritable plaisir. Jusqu'à la fin, il continua à créer des pin-up, laissant une peinture inachevée quand le cancer finit par avoir raison de lui en 1980, à l'âge de 65 ans. De sa fortune d'alors il ne restait presque rien mais son talent demeurait, vif comme jamais, et même inachevée, son ultime pin-up gardait au fond des yeux, intacte, la fameuse étincelle Elvgren.

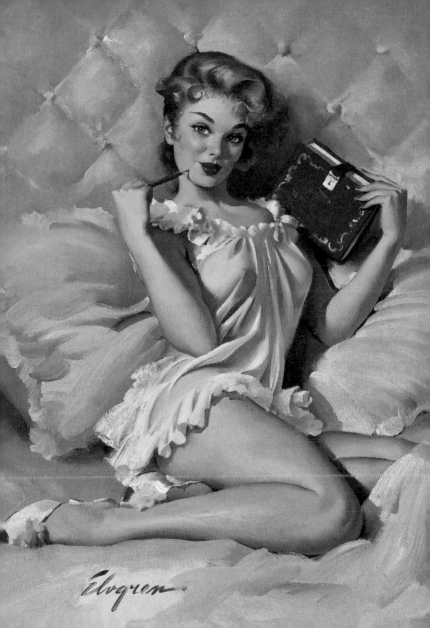

Elvgren

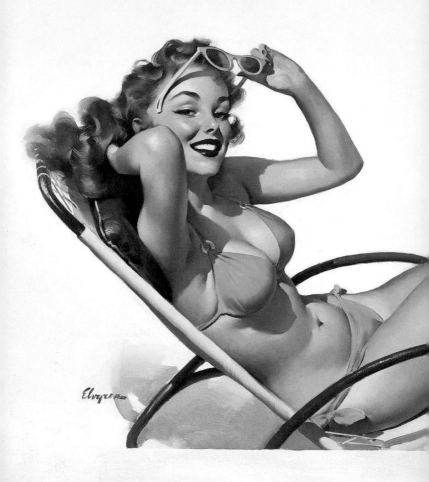

Opposite: French Dressing, 1938.

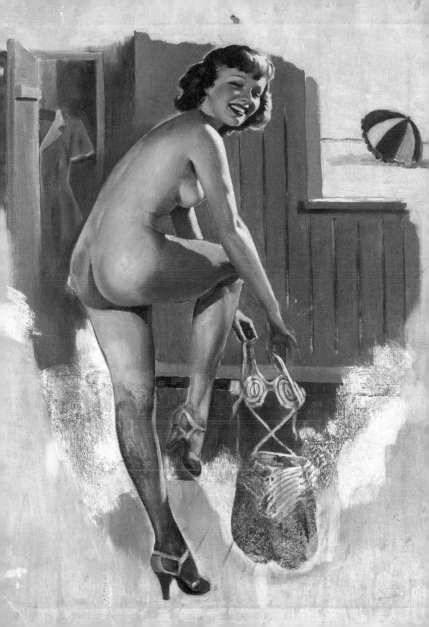

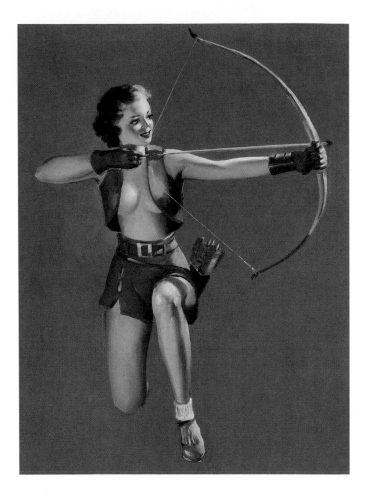

Above: *Sure Shot*, 1937.

Opposite: *Doctor's Orders*, 1939.

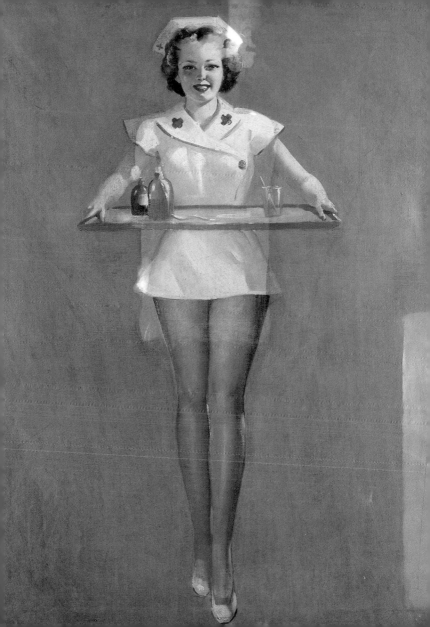

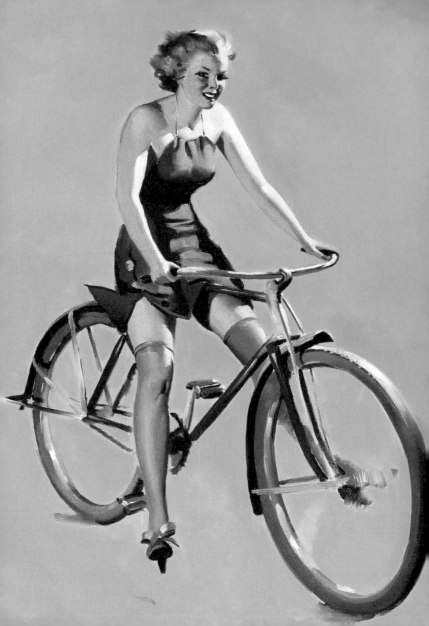

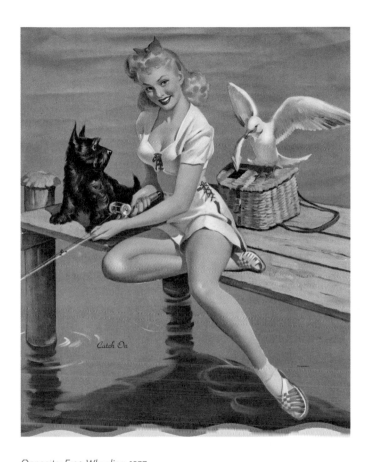

Opposite: Free Wheeling, 1937.

Above: Catch On, 1941, from a Louis F. Dow calendar.
The painting was subsequently painted over and reissued.

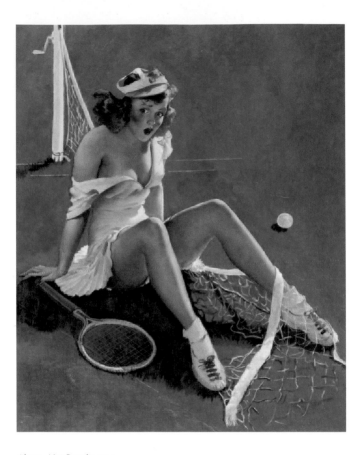

Above: Net Results, 1941.

Opposite: Forced Landing, 1937.

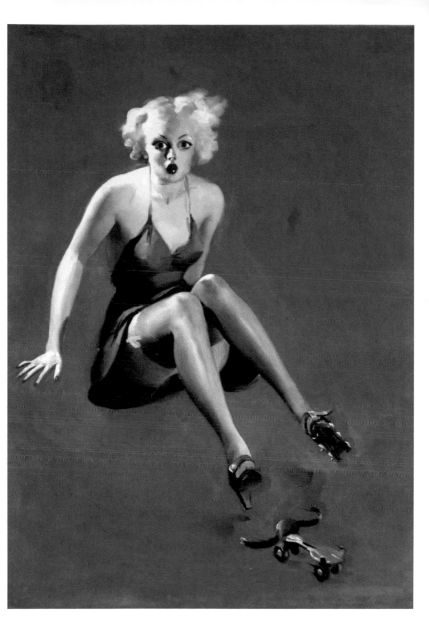

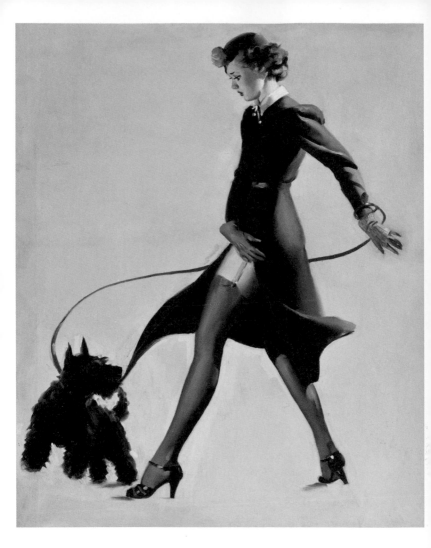

Above: Man's Best Friend, 1937.

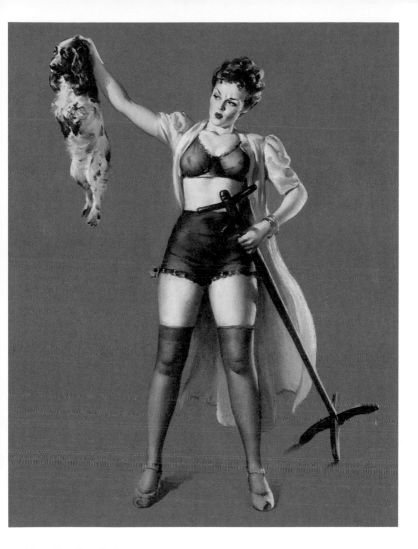

Above: Dog Done It, also known as
Mis-Placed Confidence, 1941.

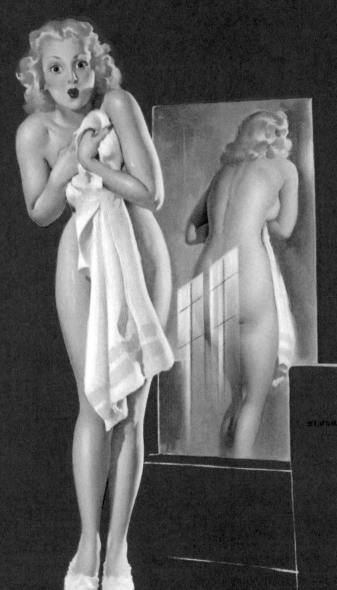

SILVGREN

DOUBLE EXPOSURE

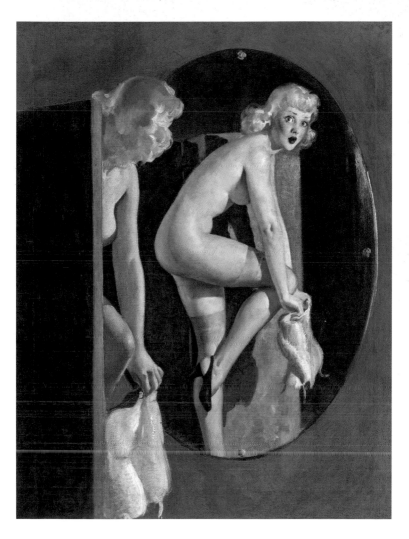

Opposite: Double Exposure, 1940.

Above: Over Exposure, 1941.

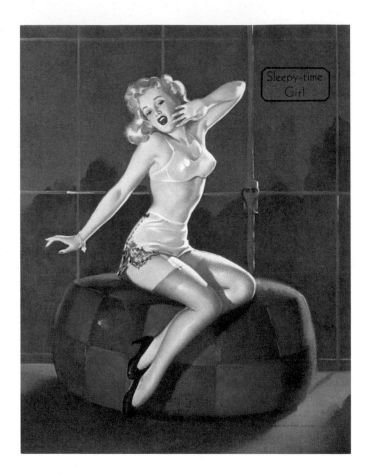

Above: *Sleepy-time Girl*, circa 1939.

Opposite: A Pleasing Discovery, 1942, on a Louis F. Dow
calendar. Elvgren produced one nude calender a year for
Louis F. Dow from 1940 through 1944.

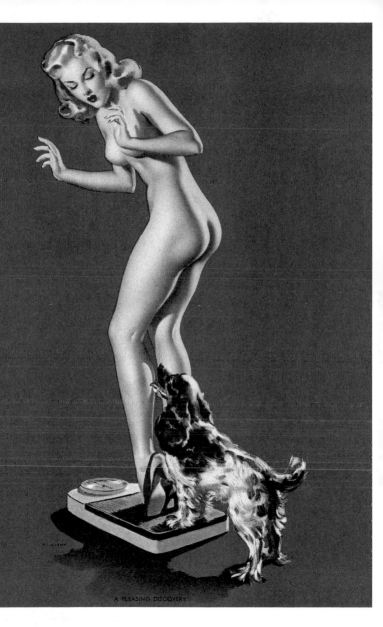

A PLEASING DISCOVERY

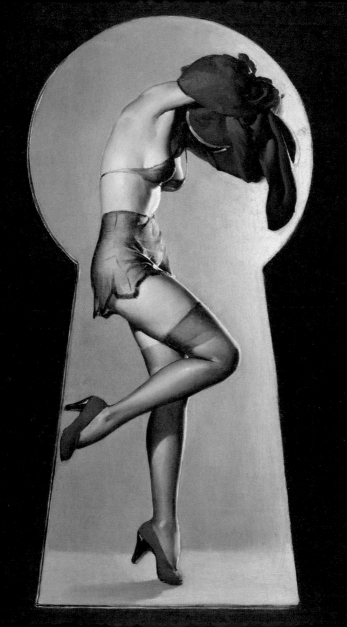

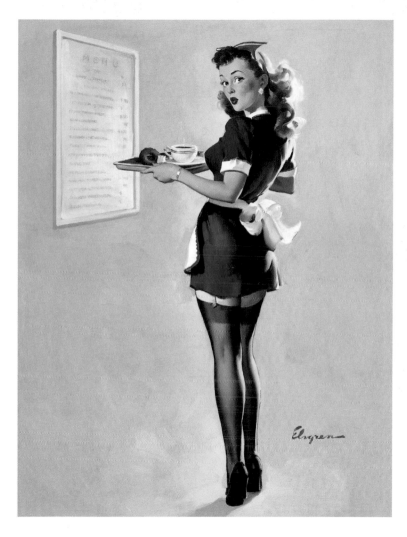

Opposite: *Peek-a-View*, 1940.

Above: *"Everything Seems Awfully High Around Here,"* 1946.

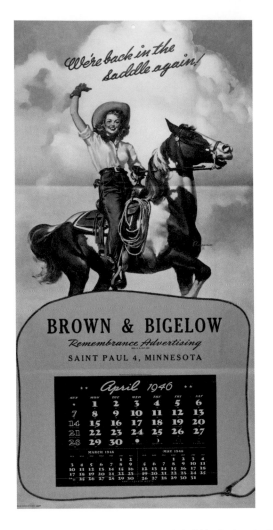

Left: We're Back in the Saddle Again!, also known as *Close Pals*, 1944, on a 1946 calendar, Elvgren's first for Brown & Bigelow.

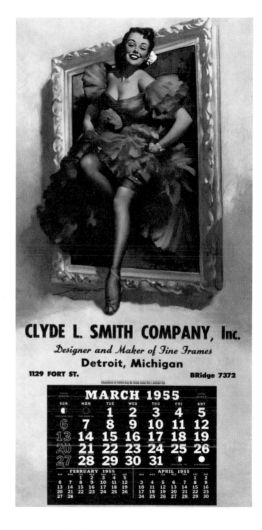

Middle: Breathless Moment, 1945, on a 1947 calendar.

Right: Stepping Out, 1953, on a 1955 calendar.

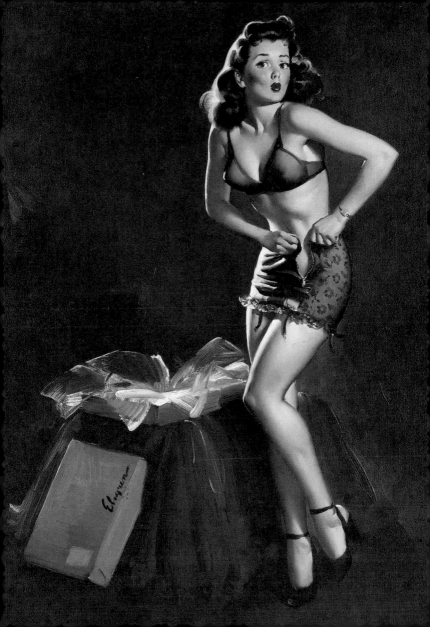

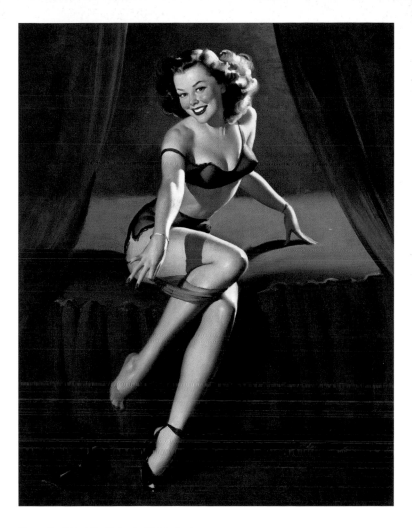

Opposite: I Must Be Going to Waist, also known
as *Waisted Effort*, 1946.

Above: I'm Not Shy, I'm just Retiring, 1947.

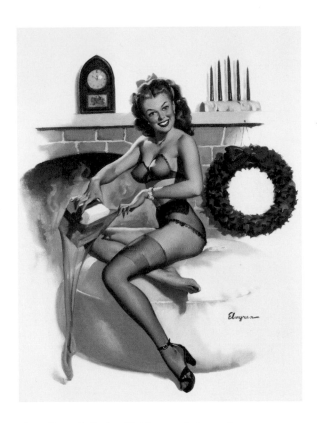

Above: Brown & Bigelow Christmas card, circa 1948.

Opposite: One of many Miss Sylvania's for the Sylvania
Electric Company, circa 1948.

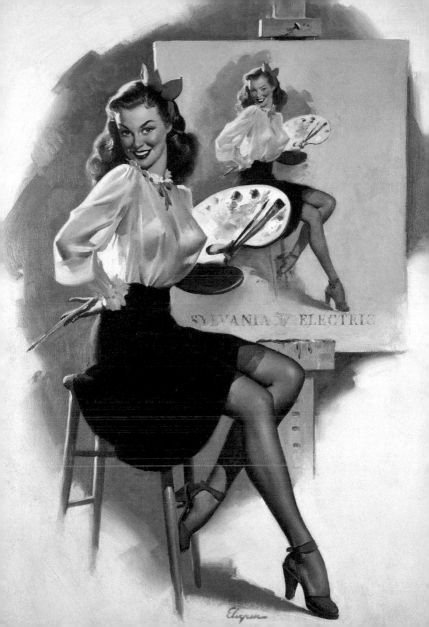

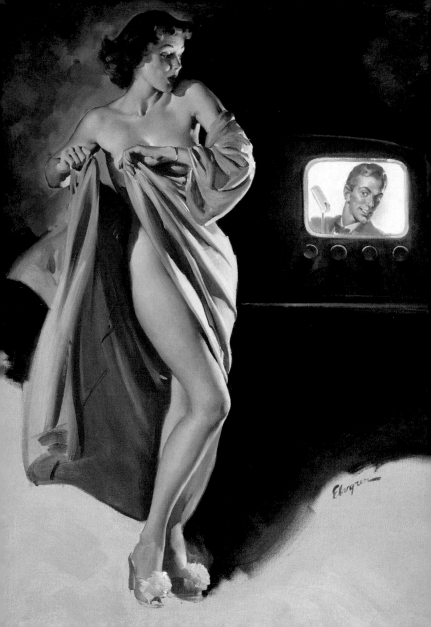

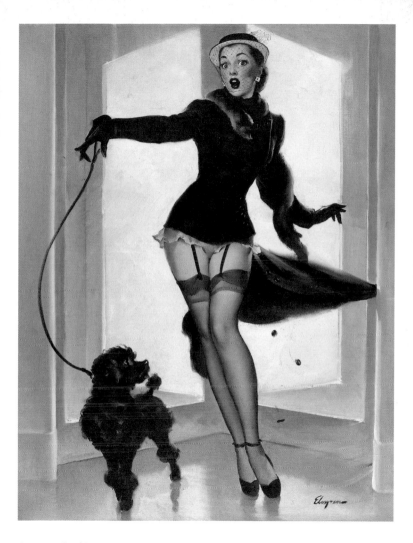

Opposite: *Fresh!*, 1949.

Above: *Skirting the Issue*, 1952.

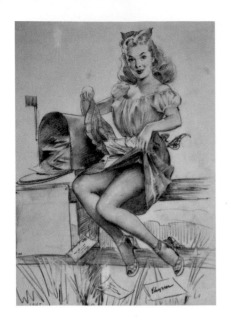

He famously described the perfect pin-up model as having the face of a 15-year-old on a 20-year-old's body.

Above: A preliminary pencil sketch for *Keeping Posted*, 1947, opposite.

Page 60: "*Doggone!*", 1946.

Page 61: The Honeymoon's Over, also known as *A Good Man's Hard to Find Once You Marry Him*, 1949.

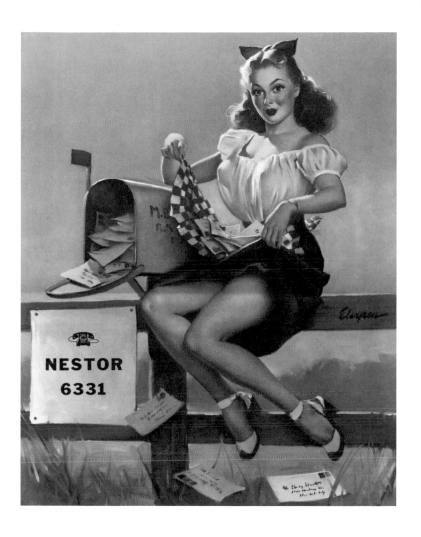

NESTOR
6331

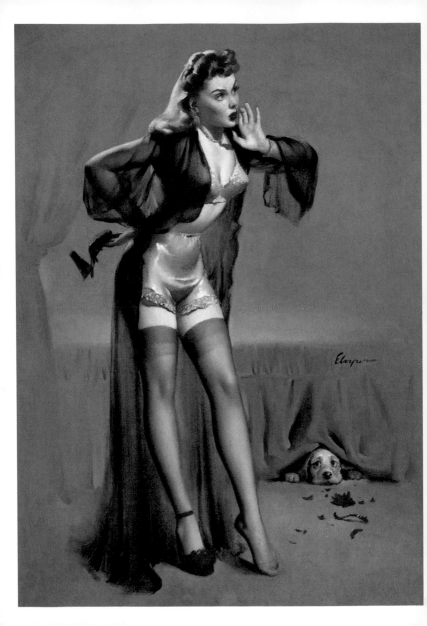

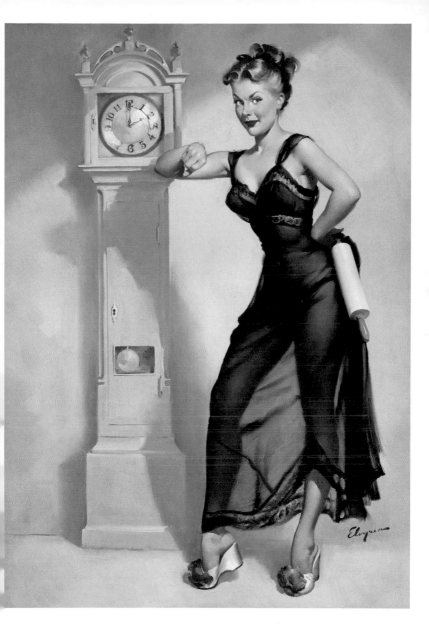

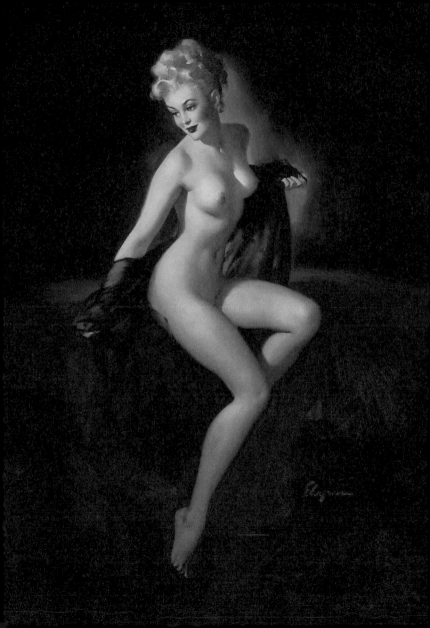

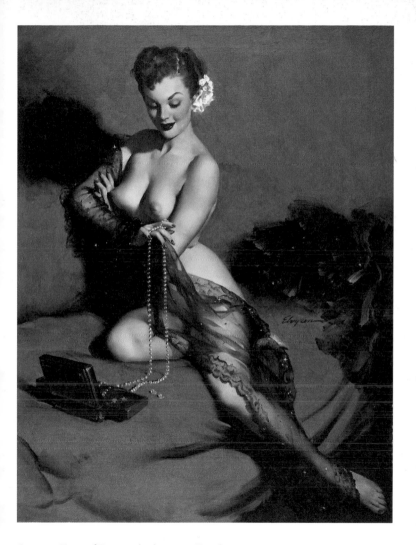

Opposite: Vision of Beauty, also known as *Unveiling*, 1947.

Above: Fascination, 1952.

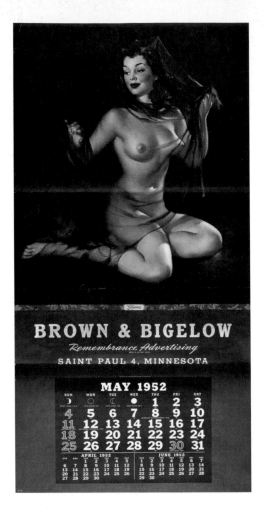

Above: Elegance, 1950, on a 1952 calendar.

Opposite: Gay Nymph, 1946, sold for $286,800 at
Heritage Auctions in 2011, the highest price paid to
date for a pin-up painting.

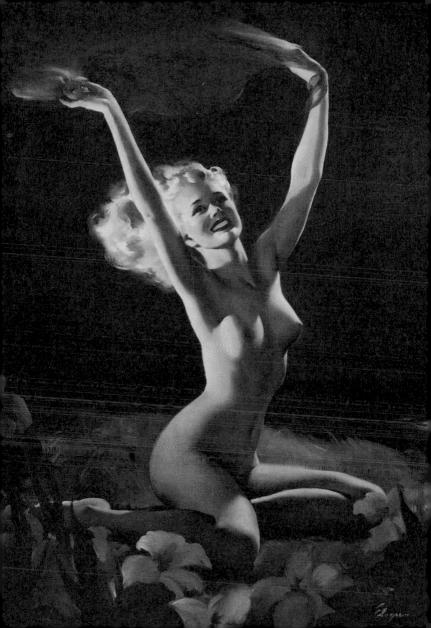

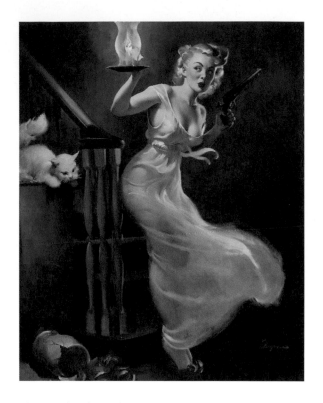

Above: Looking for Trouble, 1950.

Opposite: Sheer Delight, also known as This Soots Me, 1948.

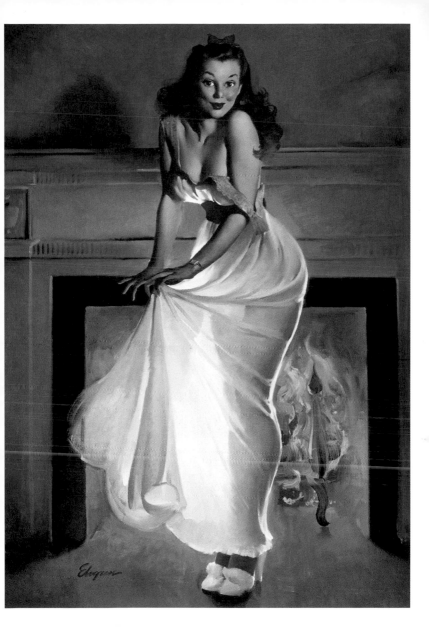

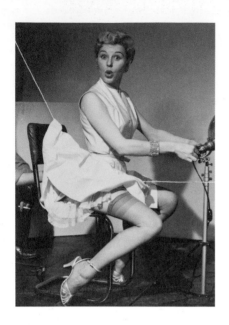

You'd think Elvgren painted from live models, but he worked exclusively from photographs, meticulously posed and personally snapped.

Above: Elvgren model Ginger Allyson posed in the reference photo for *Taking Off*, 1955, opposite.

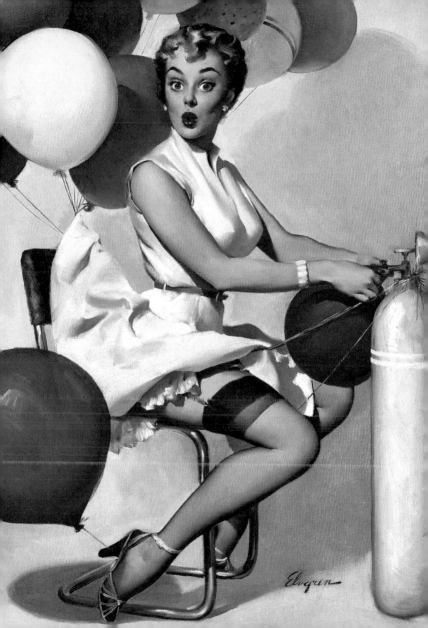

Elvgren

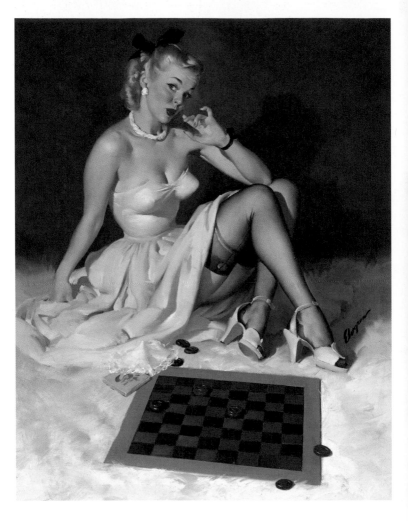

Above: *Check and Double Check*, also known as
Now Don't Get Me in a Corner, 1946.

Opposite: *Hope He Mrs. Me*, 1949.

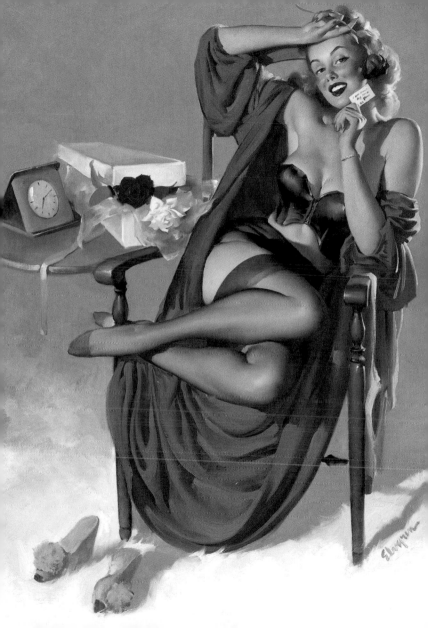

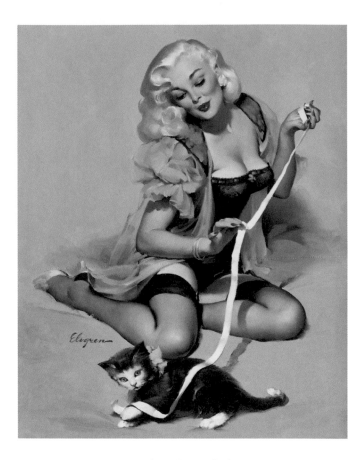

Above: Denise, also known as *Pur-r-rty Pair,* 1960.

Opposite: Making Friends, 1951.

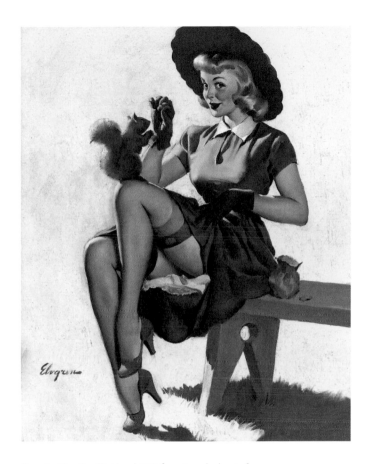

Page 74: Cee Bee (To Have), 1951, for a two-deck set of Fascinating Figures playing cards.

Page 75: Cee Bee (To Hold), 1951, for the second deck of the Fascinating Figures playing card set. The inscription is to film star Harold Lloyd.

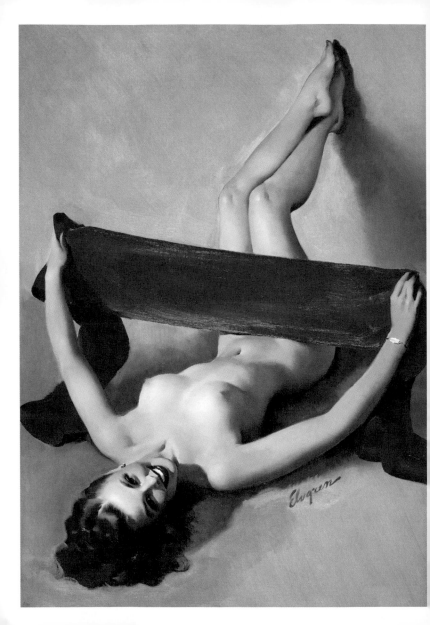

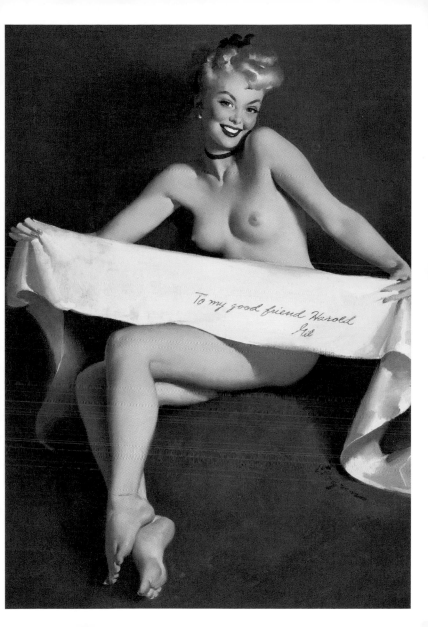

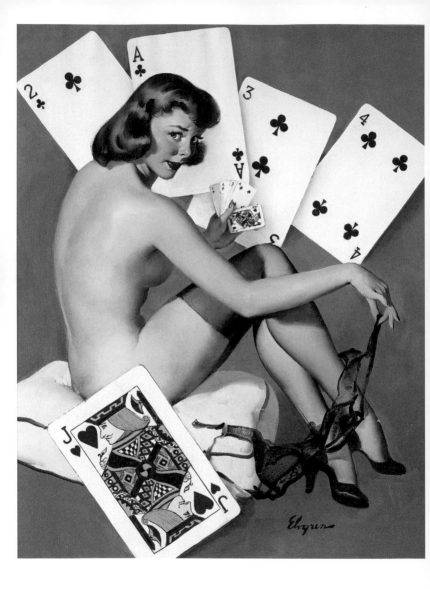

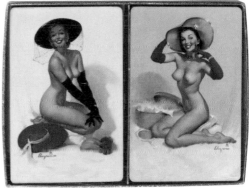

Opposite: What a Deal, 1951,

Above: A double deck of personalized Elvgren Cuties playing cards from Brown & Bigelow, circa 1960, featuring a different pin-up on the back of each deck. The two nudes were commissioned specifically for the cards and never appeared on calendars.

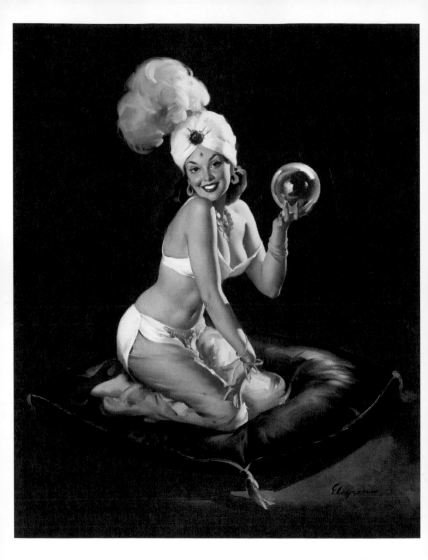

Above: I'm a Happy Medium, also known as
And Find Out How the Future Looks, 1947.

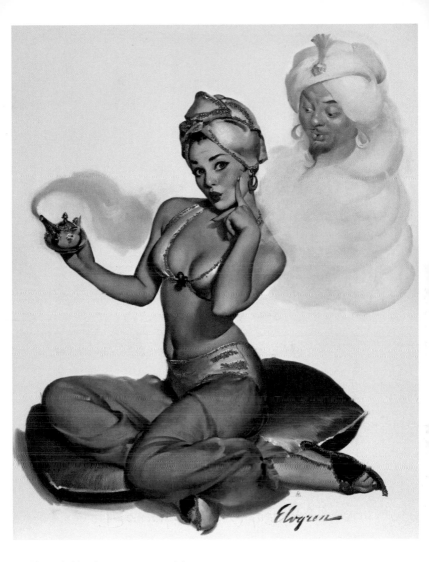

Above: At Your Service, 1962, on a deluxe 1964
Brown & Bigelow glitter-encrusted calendar.

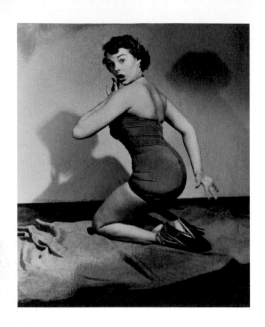

His bodies were perfectly proportioned yet still human, with flesh so realistically yielding that a man knew just how it would feel in his hands.

Above: The reference photo, posed and shot by Elvgren, for *Hard to Suit*, opposite, 1951.

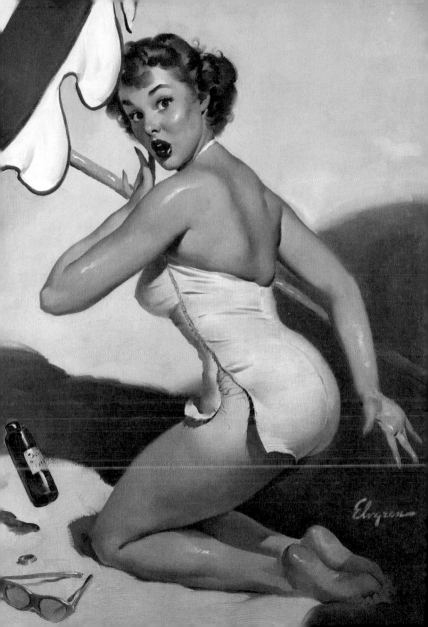

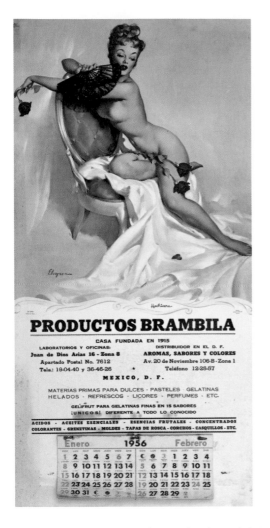

Left: Bewitching, here titled *Hechicera*, or *Sorceress*, 1955, on a Spanish language calendar.

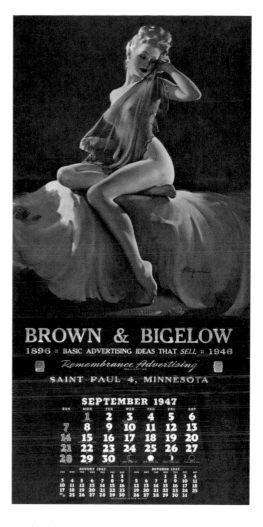

Middle: Enchanting, 1953, on a 1955 calendar.

Right: Adoration, 1945, on a 1947 calendar.

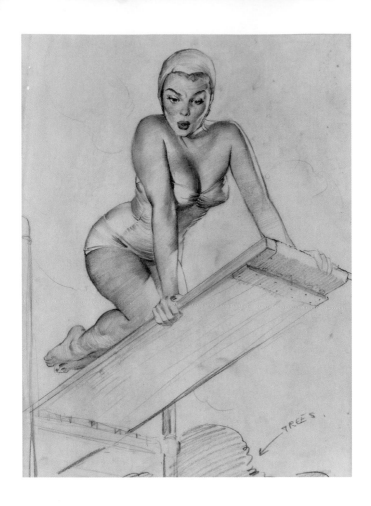

Above: Sketch for *High and Shy*, opposite, 1950.

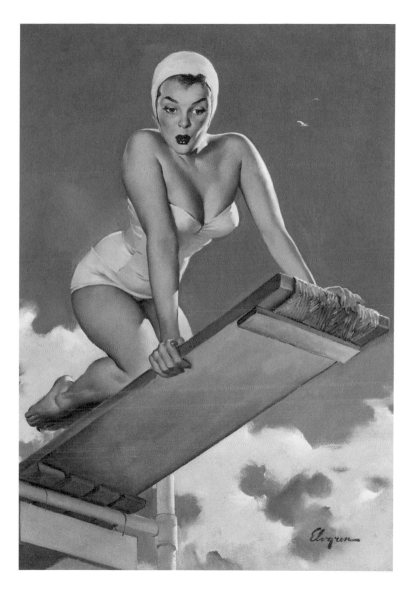

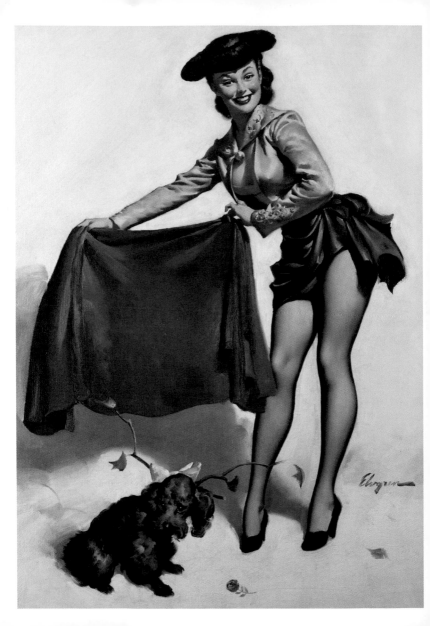

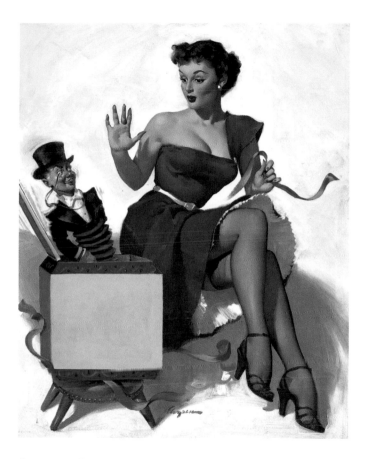

Opposite: Aw-Come On, 1953.

Above: Surprised?, 1952.

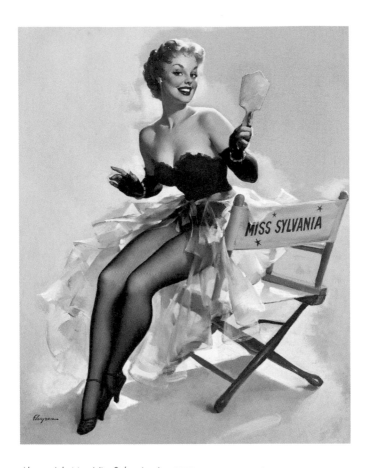

Above: Admiring Miss Sylvania, circa 1955.

Opposite: This Doesn't Seem to Keep the Chap From My Lips, 1948.

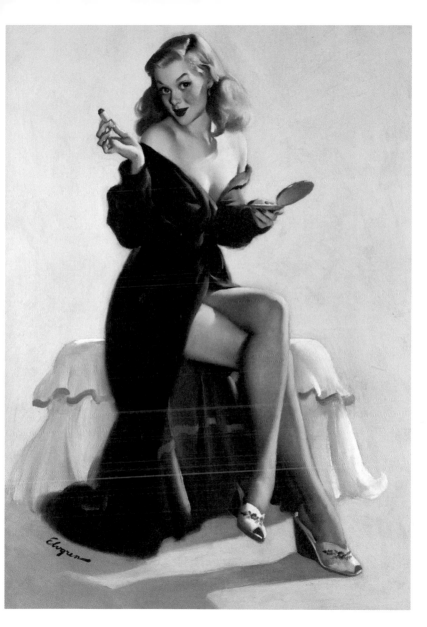

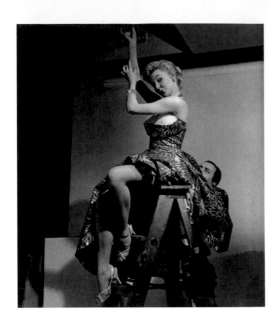

He was a complete gentleman who used a long wooden stick to gently prod his models into position, so he'd never have to touch them.

Above: Reference photo posed and shot by Elvgren for *A Put-Up Job*, opposite, 1955.

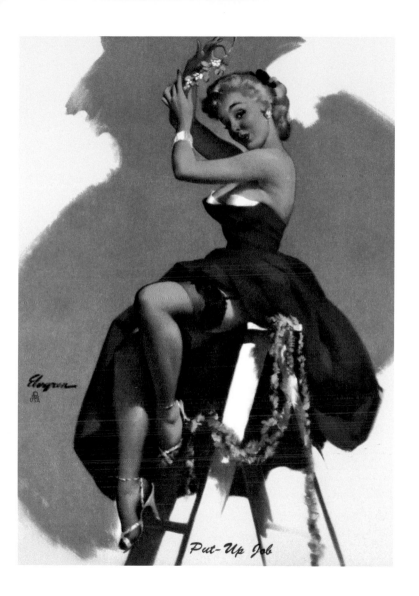

Put-Up Job

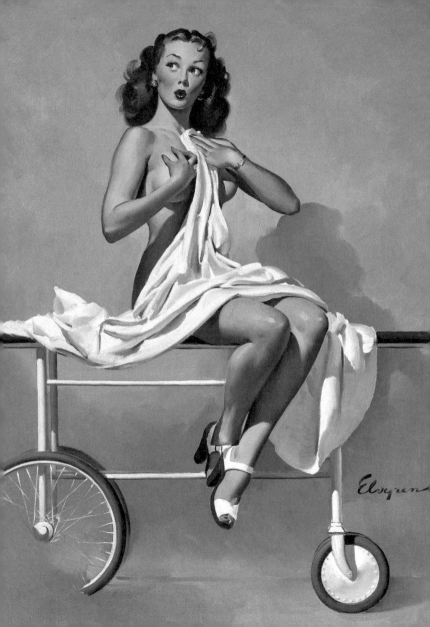

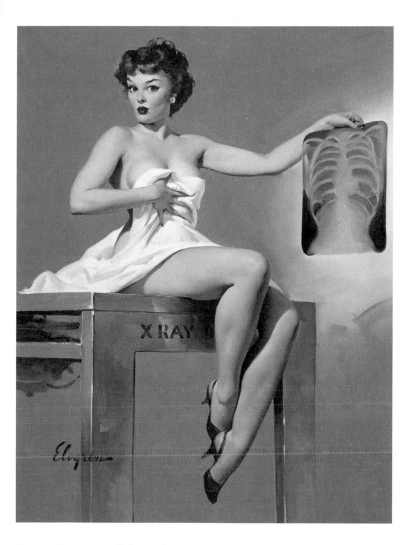

Opposite: Doctor, Are All Those Fellows Interns?, 1946.

Above: Inside Story, also known as *Over-Exposure*, 1959.

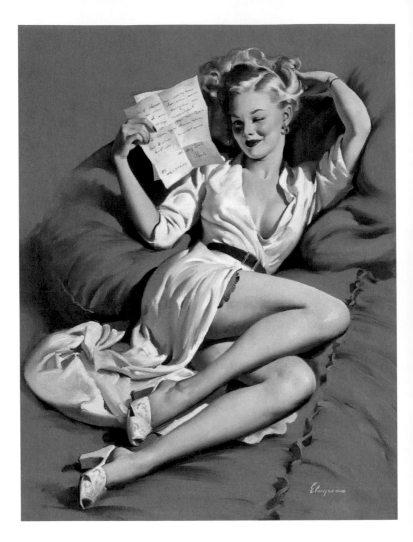

Above: He Thinks I'm Too Good to be True, 1947.

Opposite: Charmaine, 1957.

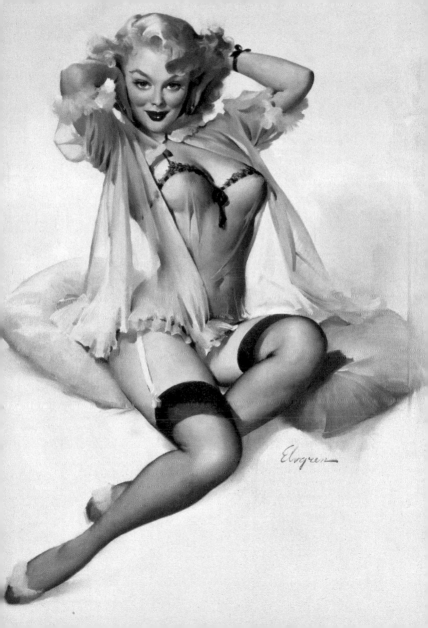

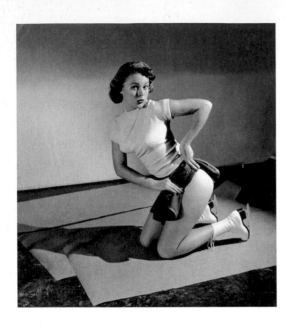

He was a highly motivated and determined student who took day and night classes, packing three years of study into two.

Above: Reference photo posed and shot by Elvgren for
A-Cute Injury, opposite, 1953.

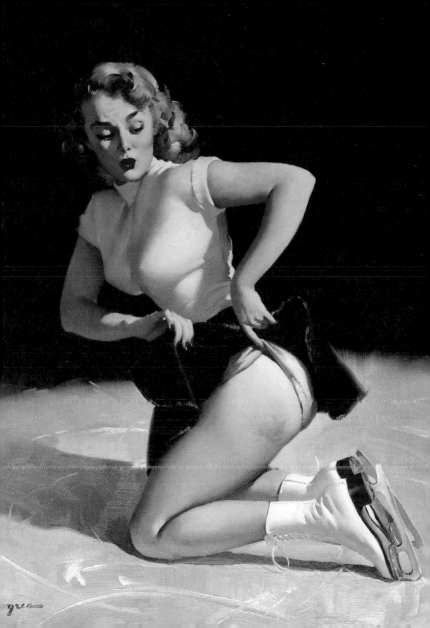

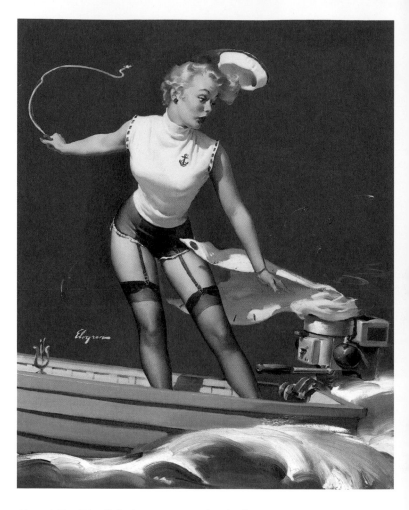

Above: A Fast Takeoff, also known as *A Speedy Takeoff*, 1954.

Opposite: Skirting the Issue, 1956.

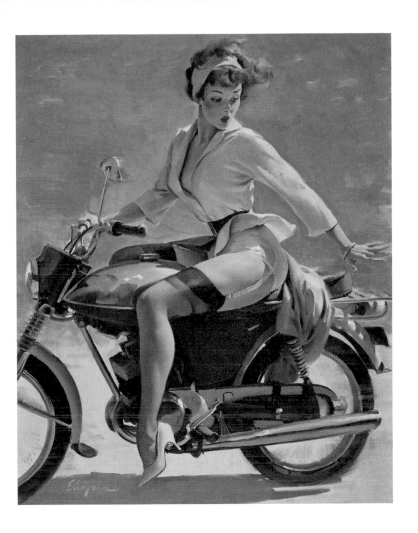

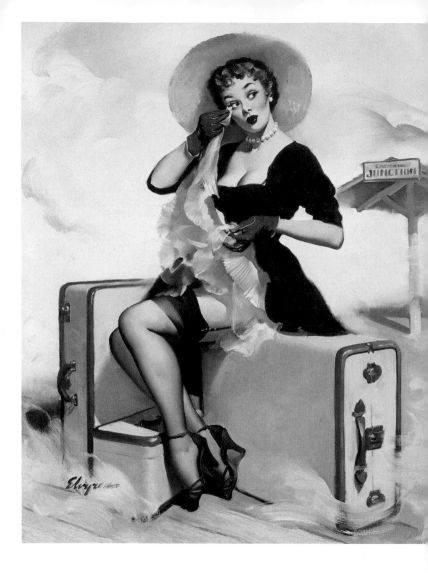

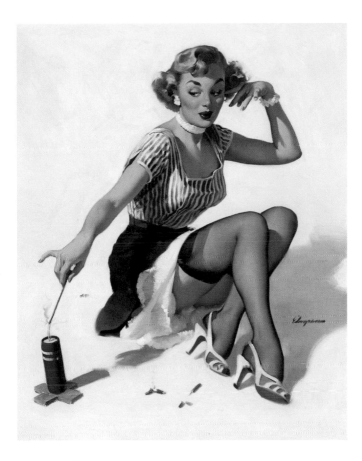

Opposite: *Welcome Traveler*, 1955.

Above: *Looking For Trouble*, 1953.

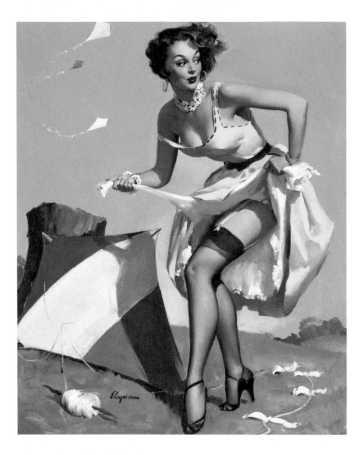

Above: The Final Touch, also known as *Keep 'Em Flying*, 1954.

Opposite: Unexpected Lift, also known as *A Nice Catch*, 1961.

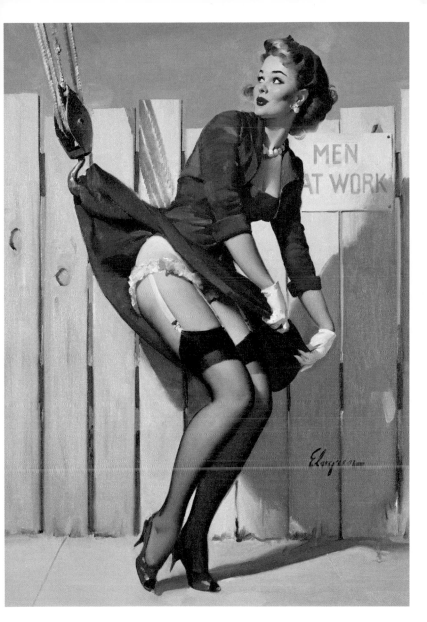

It was called the "mayonnaise school" for its thick, swirling application on canvas...but none applied the mayo as deftly as Elvgren.

Above: A signed reference photo of model Myrna Hansen for *Toast of the Town*, 1955.

Opposite: Cover Up, 1957.

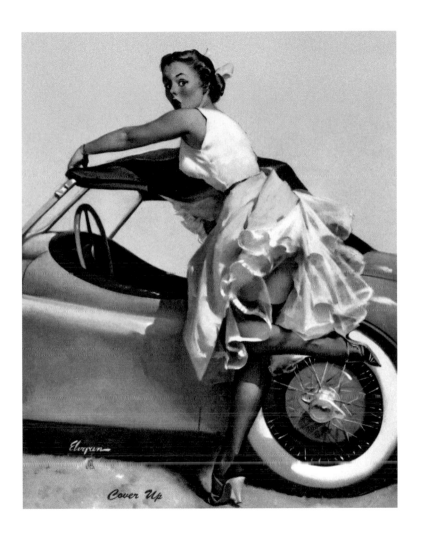

Cover Up

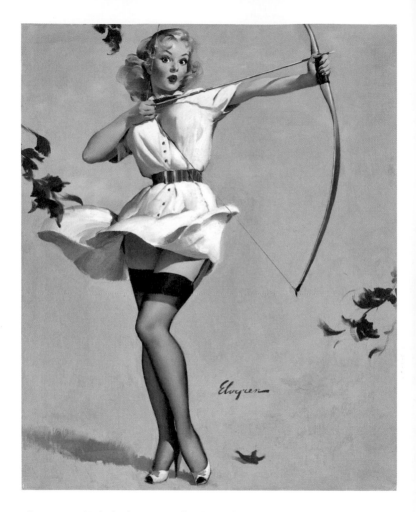

Above: *Aiming High*, also known as *Will William Tell?*, 1959.

Opposite: *A Near Miss*, also known as *Right on Target*, 1964.

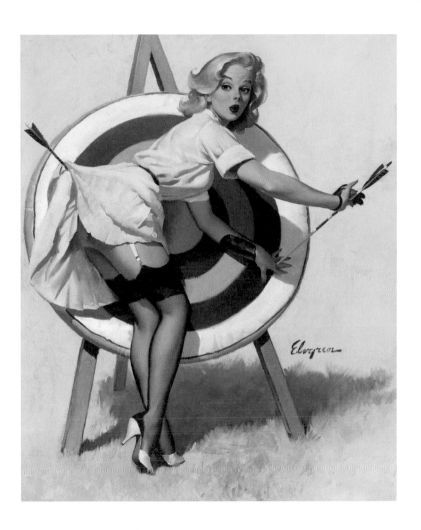

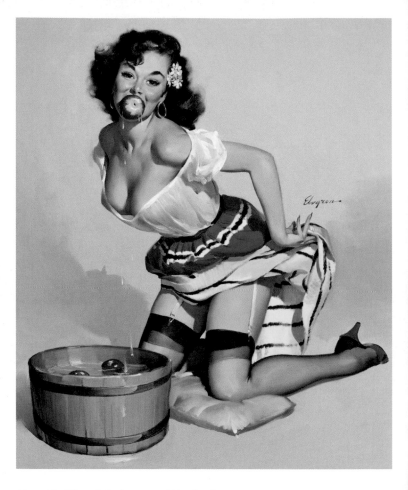

Above: The Winner!, also known as *A Fair Catch!,* 1957.

Opposite: It's a Snap, also known as *Pretty Snappy,*
and *Snap Judgment,* 1958.

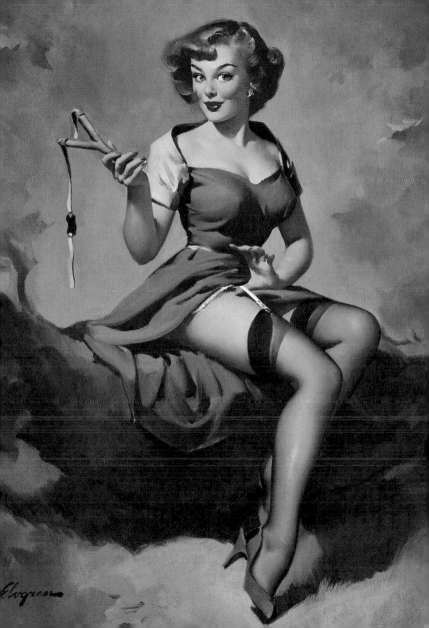

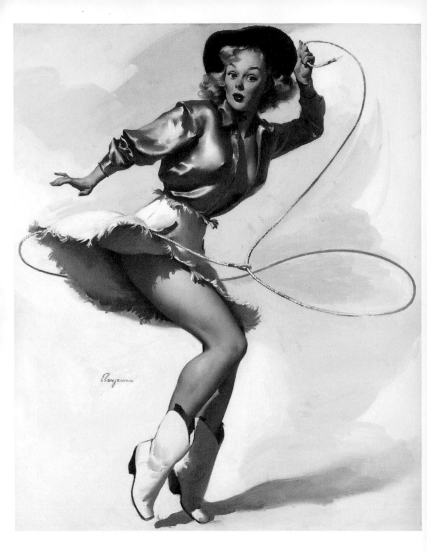

Above: On Her Toes, 1954.

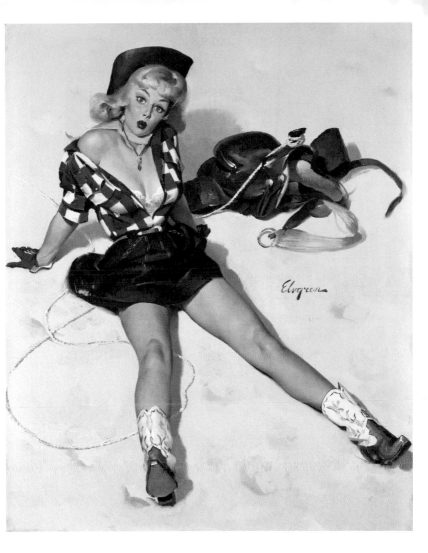

Above: Bronco Bested, also known as Bronco Busted, 1965.

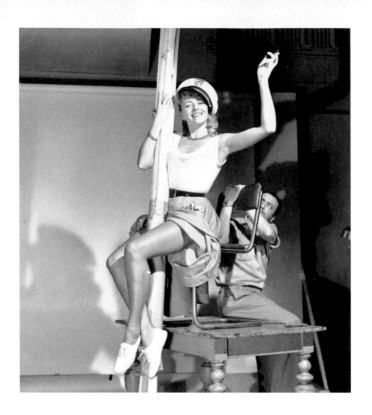

Above: Preliminary photo for *Anchors A-Wow*, showing
the difficulty a real woman would have holding such a pose
clinging to a mast. Not only is a chair required to hold the
model, but an assistant has to keep the chair in place.

Opposite: Sitting Pretty, 1953.

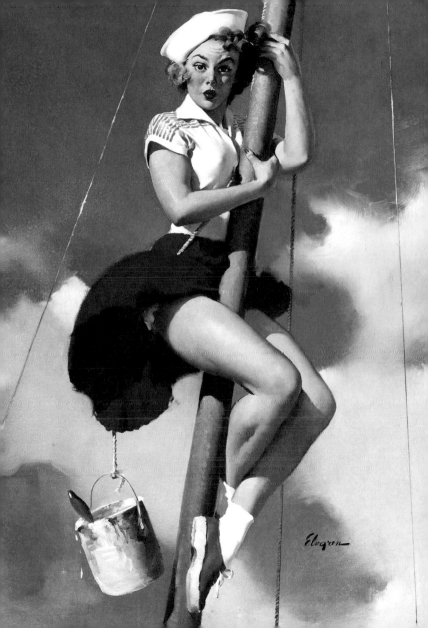

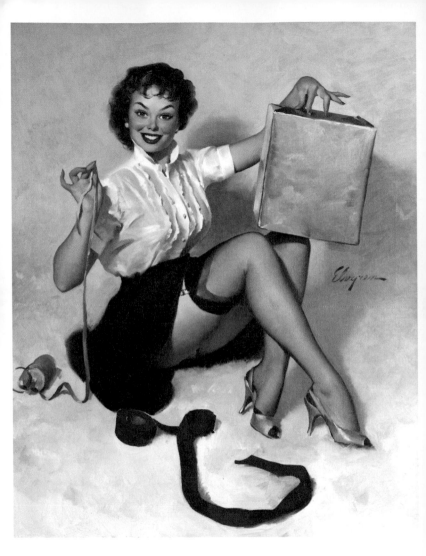

Above: A Neat Package, 1961.

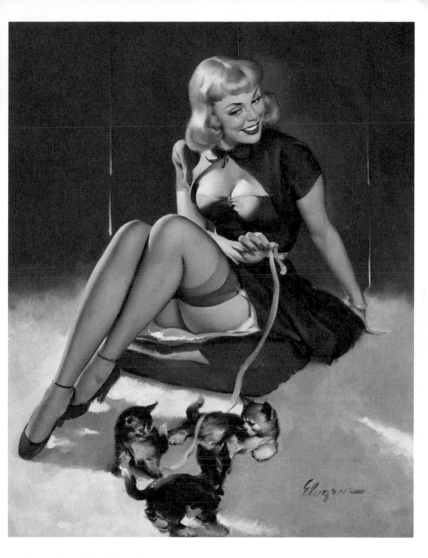

Above: Some Cute Tricks, 1951.

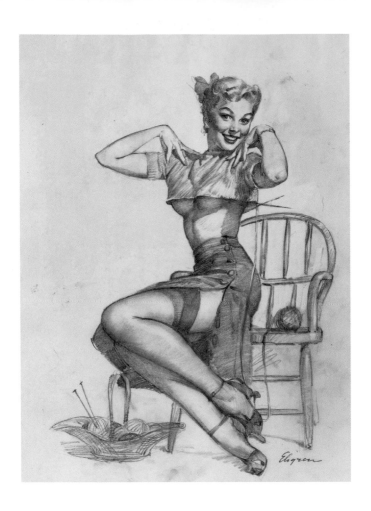

Above: A preliminary pencil sketch for
A Spicy Yarn, opposite, 1952.

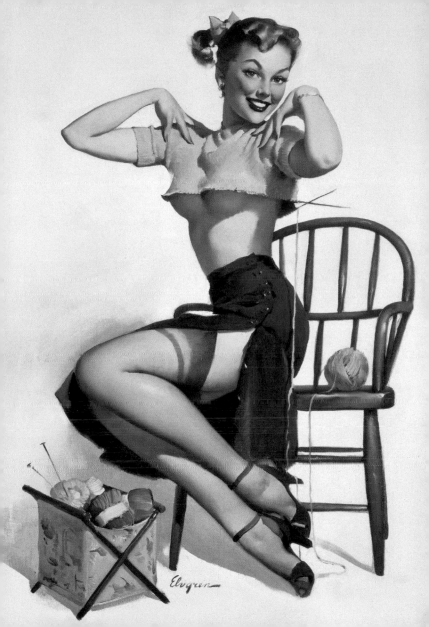

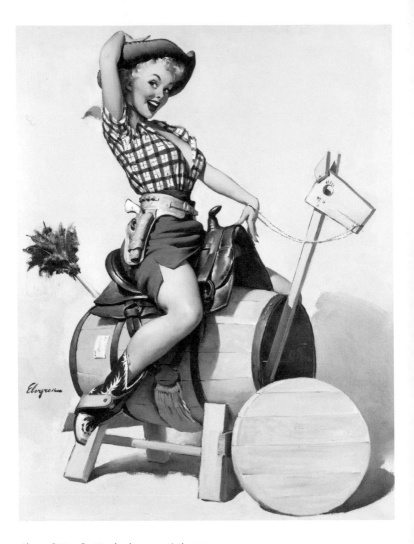

Above: *Sitting Pretty*, also known as *Lola*, 1955.

Opposite: *Fire Belle*, also known as *Always Ready*, 1956.

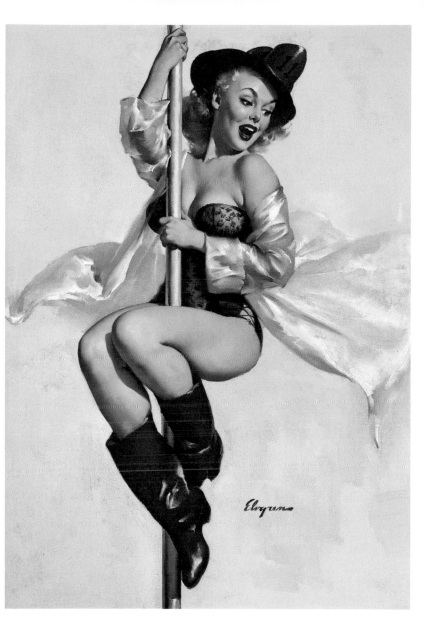

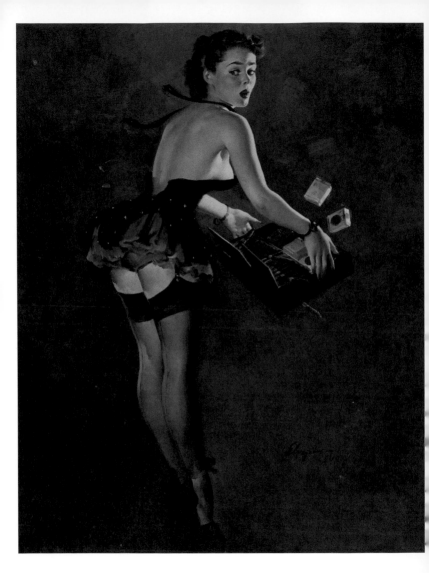

Above: Parting Company, 1950.

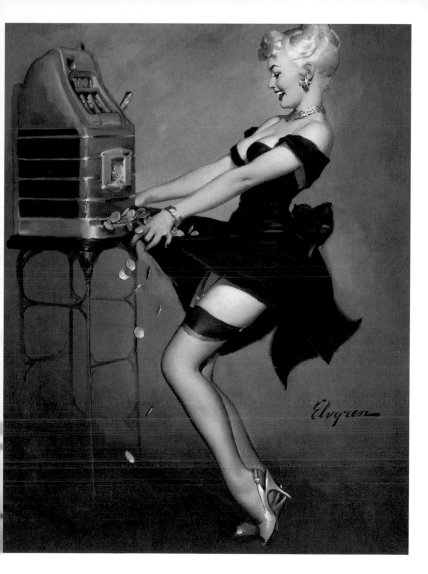

Above: Pot Luck, 1961.

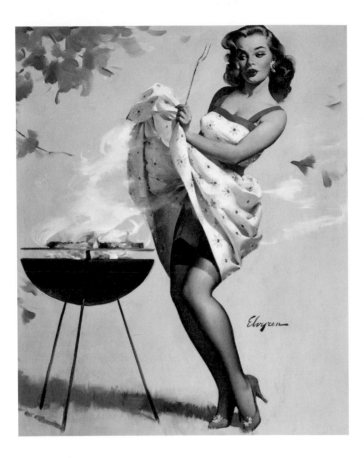

Above: *Smoke Screen*, 1958.

Opposite: *Barbacutie*, also known as *Rare Treat*, 1965.

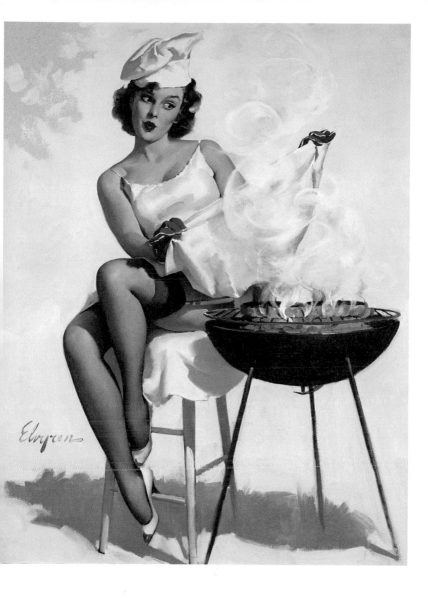

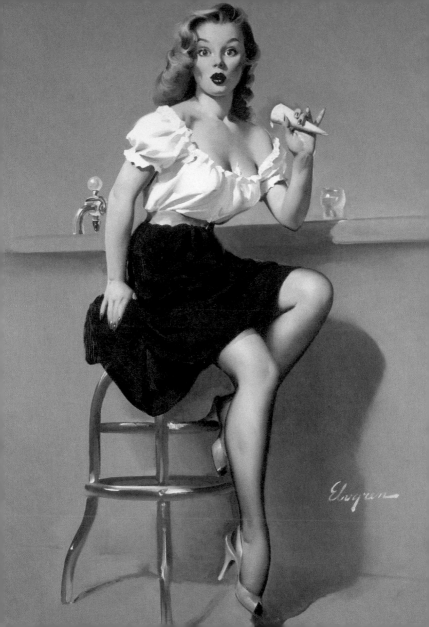

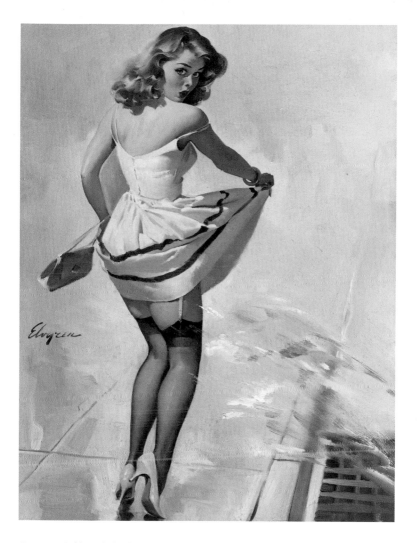

Opposite: Cold Feed, also known as *Cold Front*, 1958.

Above: Dampened Doll, 1967.

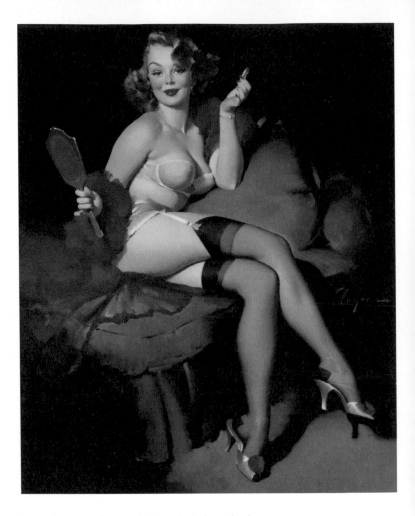

Above: Gina, 1959, from a 1961 Brown & Bigelow calendar.

Opposite: Roxanne, 1960.

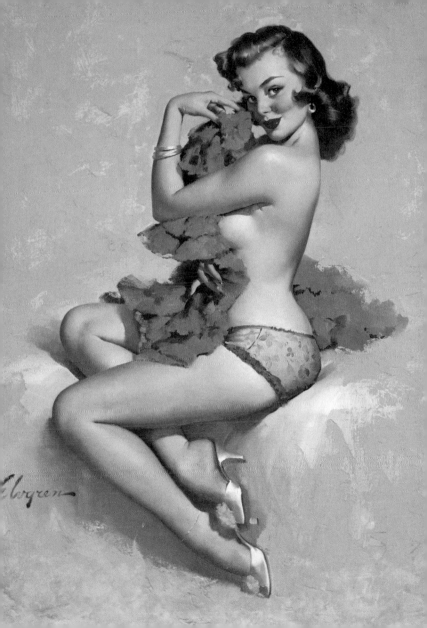

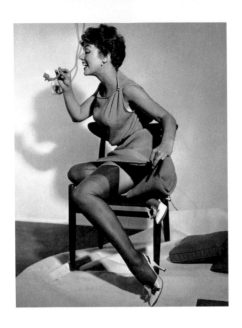

By 1946, everything we love was in place: luminous skin, soft flesh, radiant smile and inviting warmth.

Above: Reference photo posed and shot by Elvgren for *Neat Trick*, opposite, 1953.

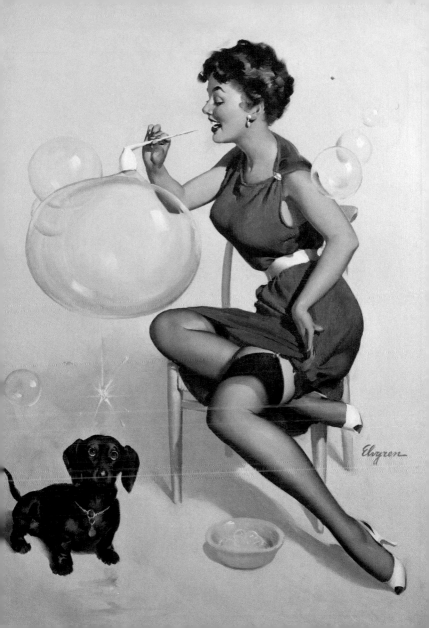

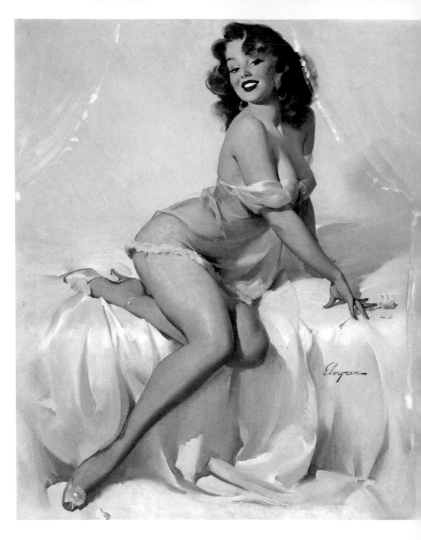

Above: Darlene, also known as *Bedside Manner*, 1958.

Opposite: Look Out Below, also known as *Easy Does It*, 1956.

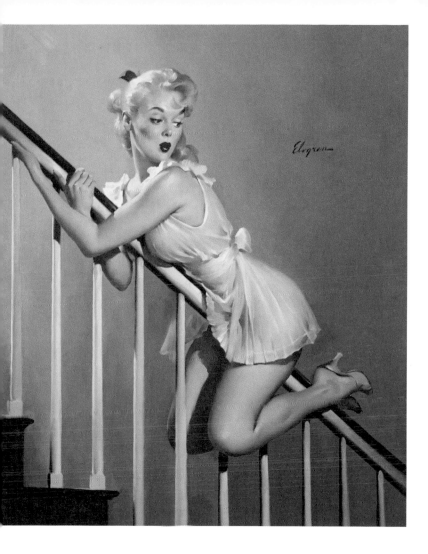

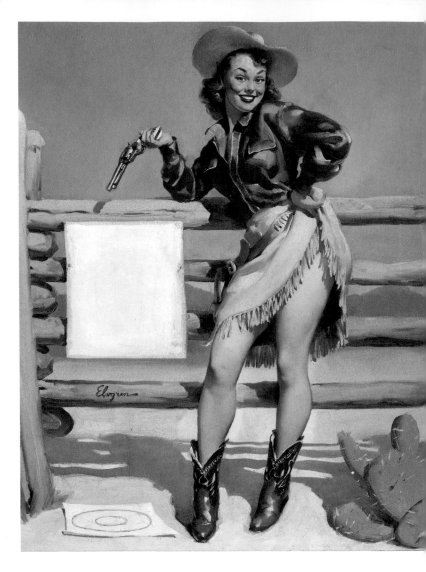

Above: Beat That!, 1953.

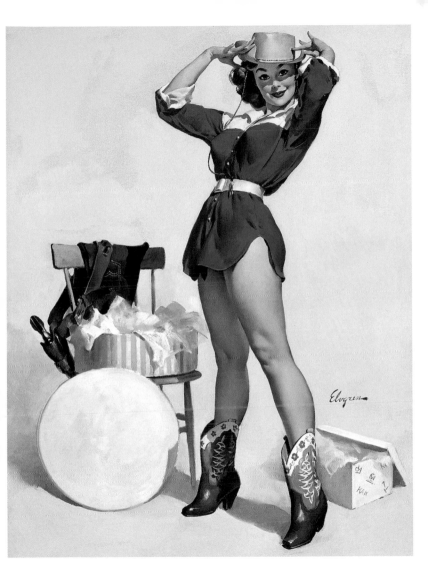

Above: Something New, 1957.

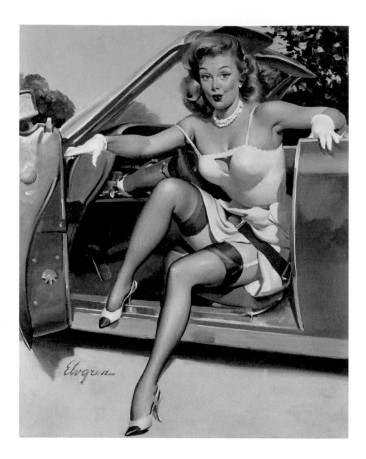

Above: Stepping Out, also known as *Stepping High*, circa 1958.

Opposite: Curving Around, also known as *Sharp Curves*, 1960.

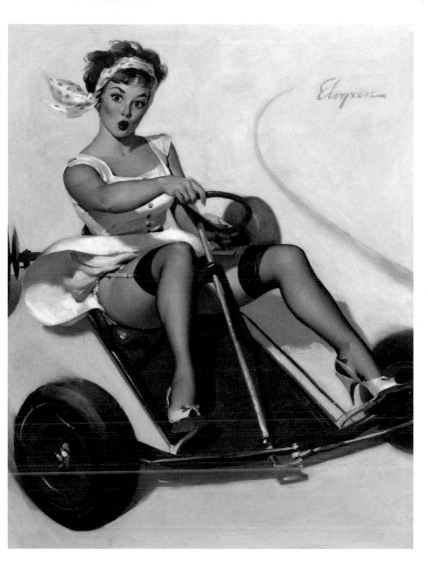

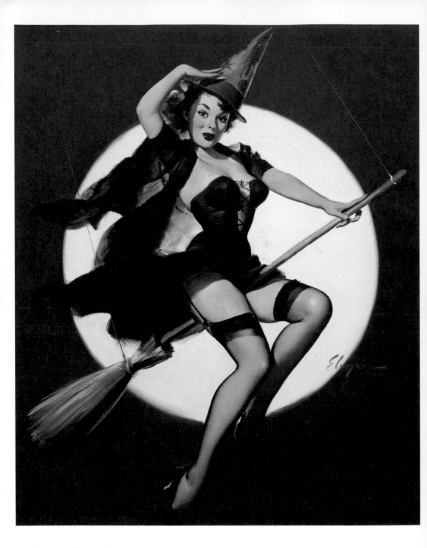

Above: Riding High, 1958.

Opposite: Bare Essentials, 1957.

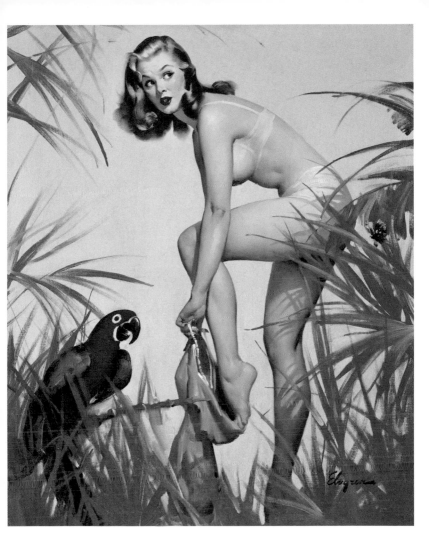

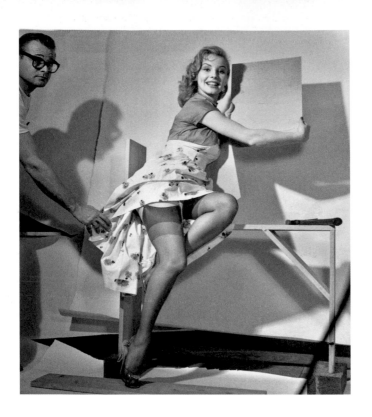

Above: Elvgren's assistant Bobby Toombs poses
Myrna Hansen for a reference photo for *It's Up to
You,* opposite, 1958.

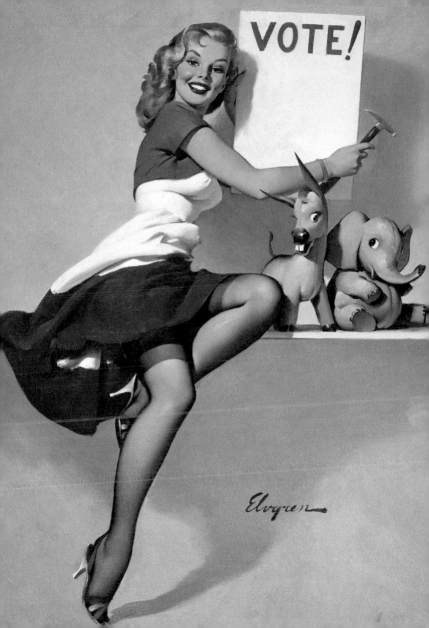

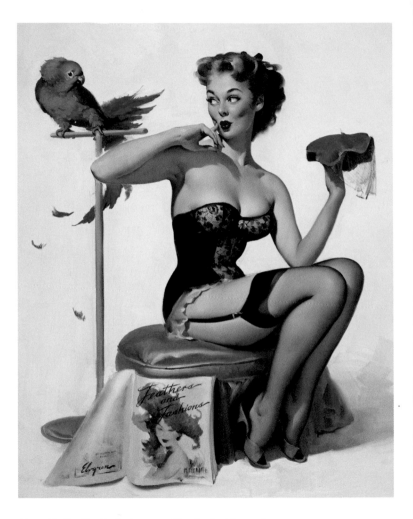

Above: No You Don't!, also known as *Time for Decision,* 1956.

Opposite: Ticklish Situation, 1957.

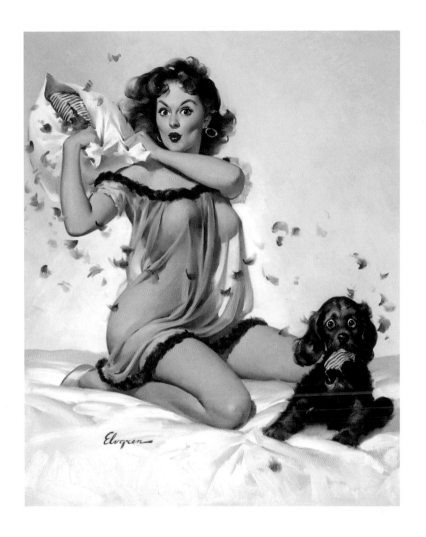

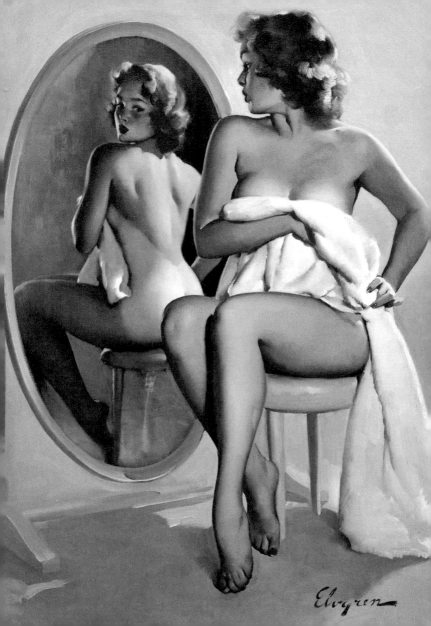

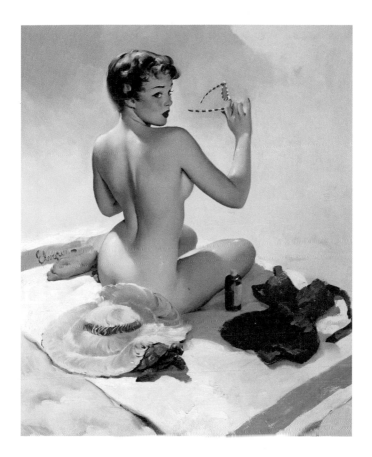

Opposite: *Partial Coverage*, also known as *Flashback* and *Sunnyside Up*, 1960.

Above: Shell Game, also known as *Shell Shocked*, 1959.

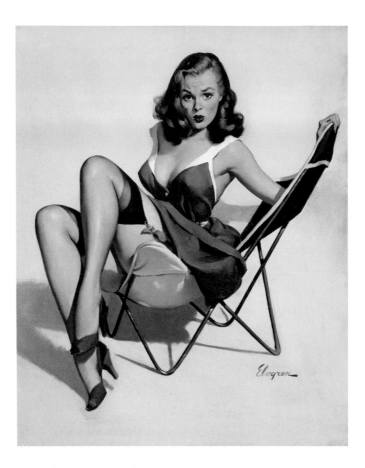

Above: That Low-Down Feeling, 1957.

Opposite: The Finishing Touch, also known as
Polished Performance, 1960.

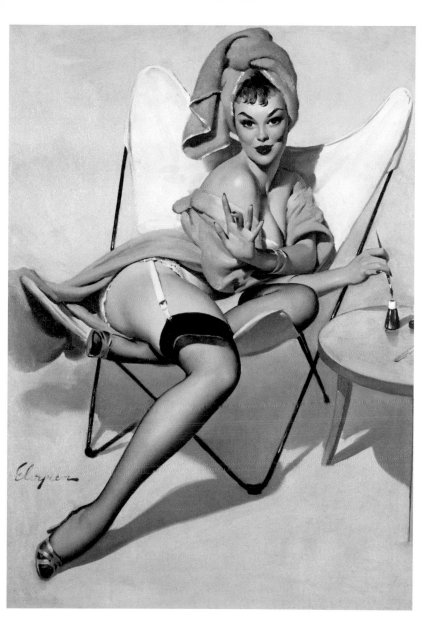

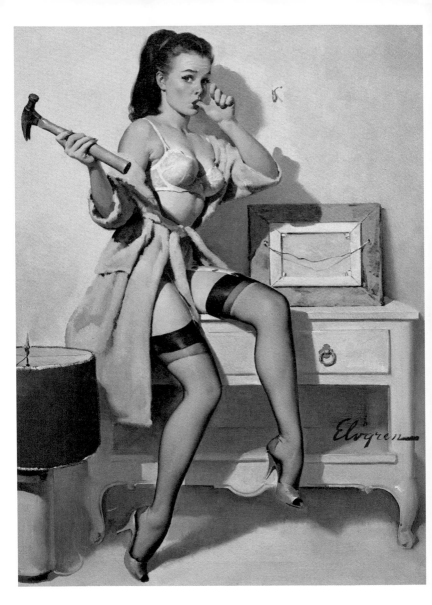

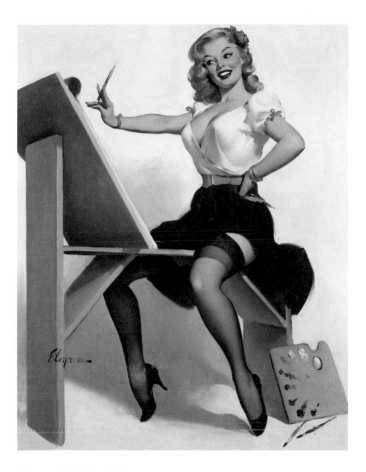

Opposite: *The Wrong Nail*, 1967.

Above: *The Right Touch*, 1958.

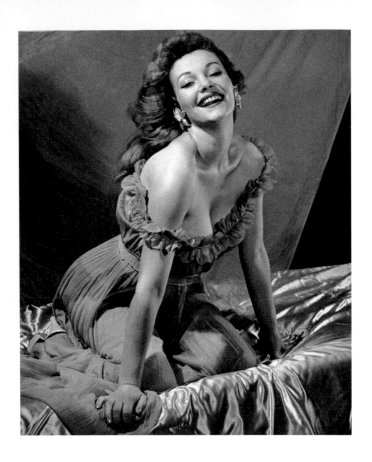

Above: Reference photo for *Mimi*, also known as *Waiting For You* and *Sweet Dreams*, opposite, 1956.

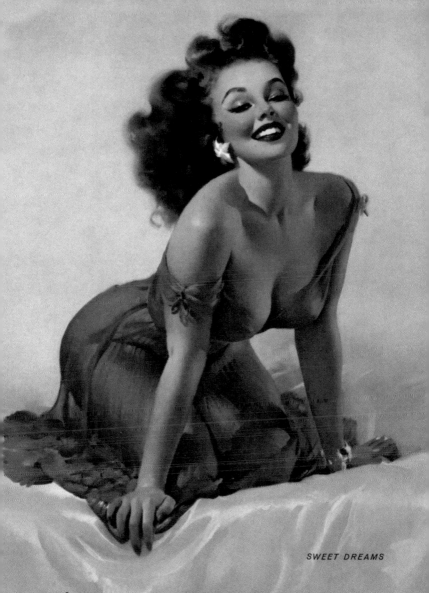

SWEET DREAMS

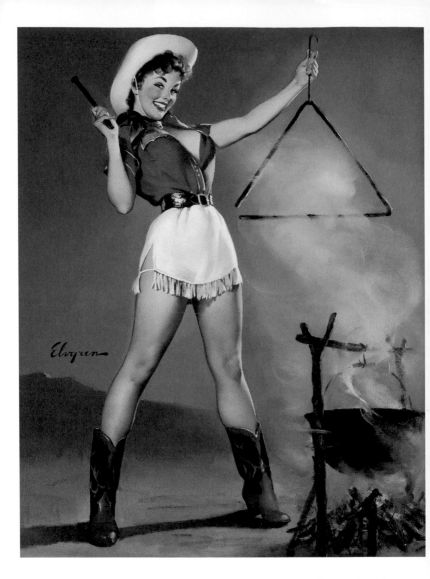

Above: Come and Get It, 1959.

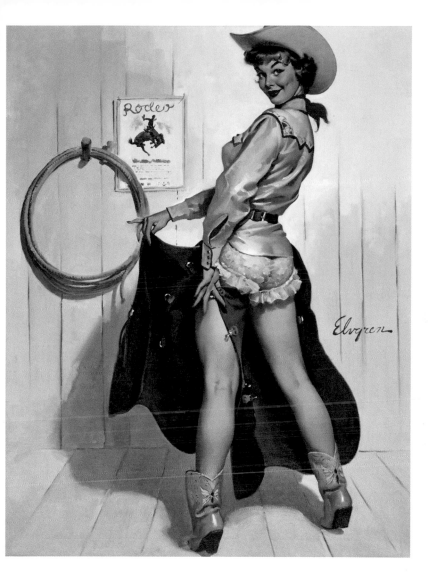

Above: Lucky Chaps, 1962.

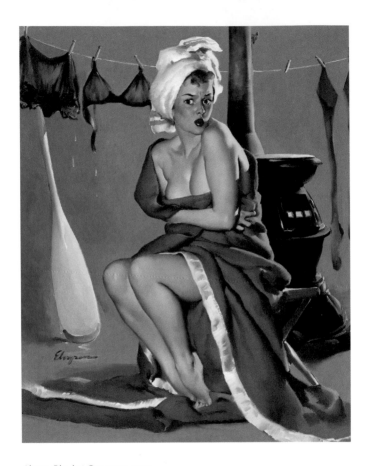

Above: *Blanket Coverage*, 1952.

Opposite: *Weighty Problem*, also known as *Starting at the Bottom*, 1962.

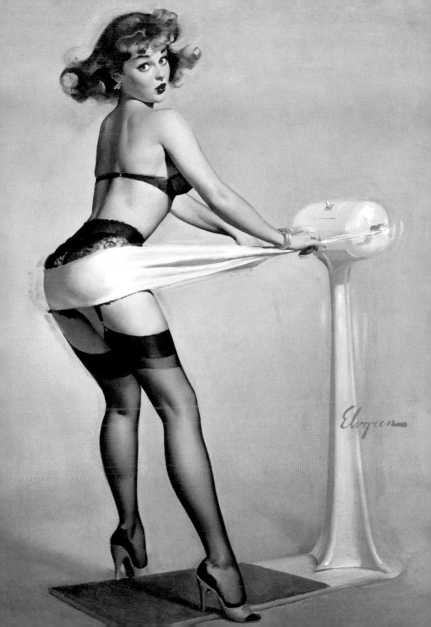

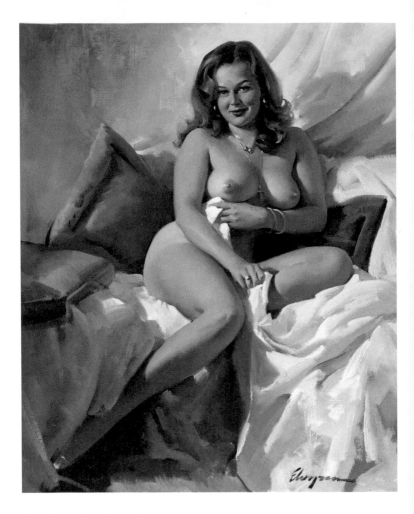

Above: Untitled nude, possibly a private
commission, circa 1965.

Opposite: *Sheer Comfort*, 1959.

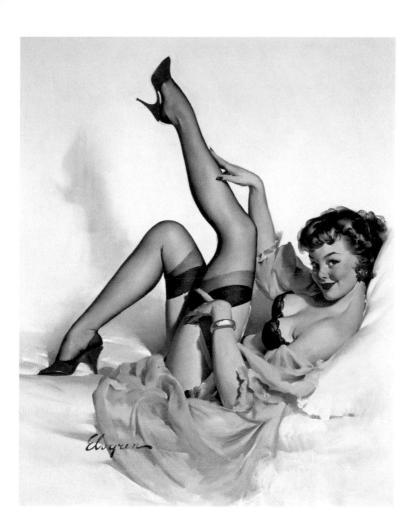

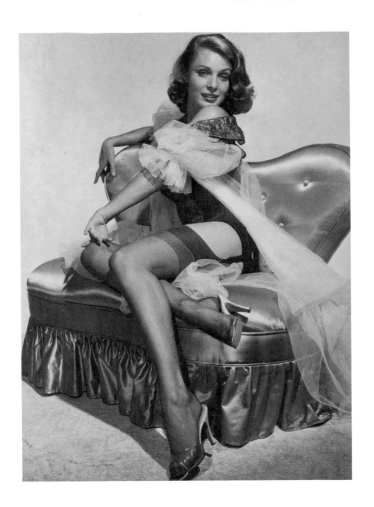

Above: Reference photo posed and shot by Elvgren
for *Mona*, 1959, opposite, on a 1961 Brown & Bigelow
calendar.

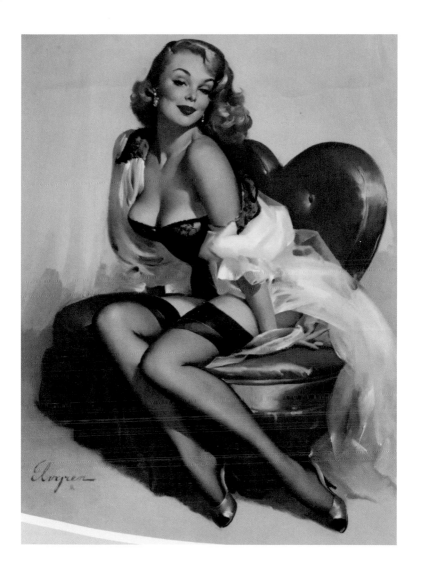

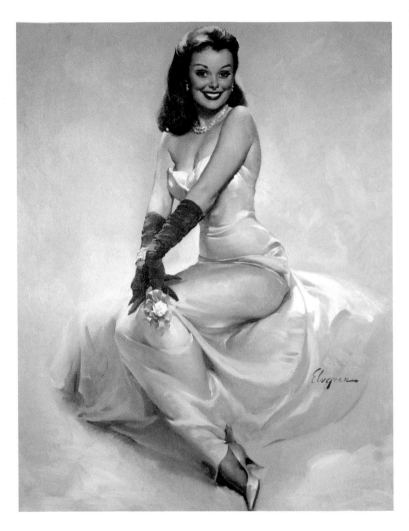

Above: Beautiful Lady, 1966.

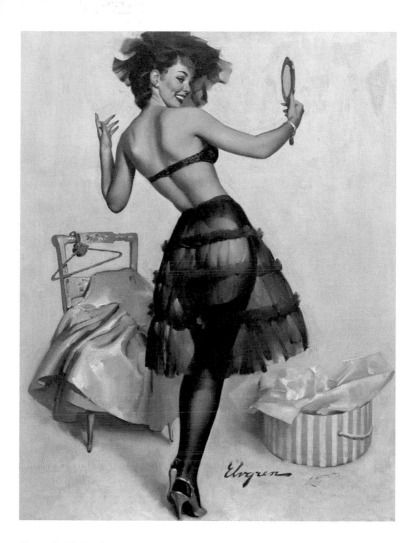

Above: Just Right, also known as
The Eyeds of March, 1962.

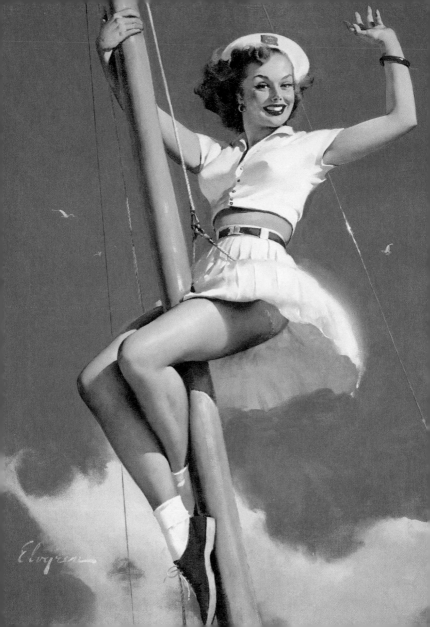

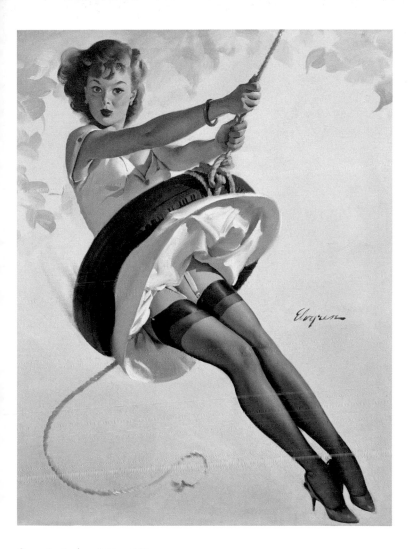

Opposite: Anchors A-Wow, 1968.

Above: Swingin' Sweetie, 1968.

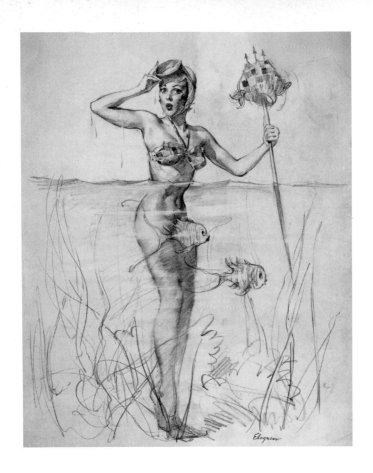

Above: A pencil on vellum preparatory sketch for
Surprising Catch, opposite, 1951.

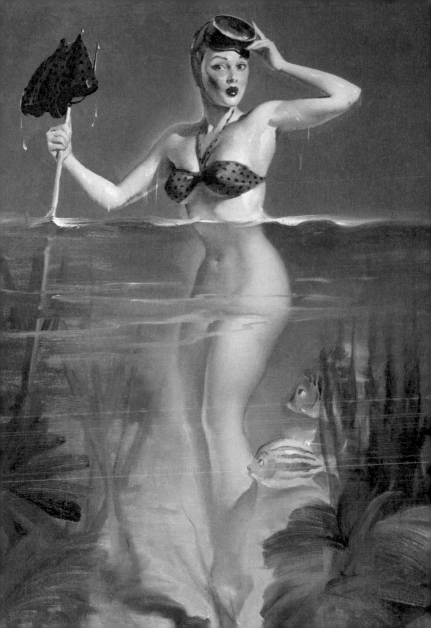

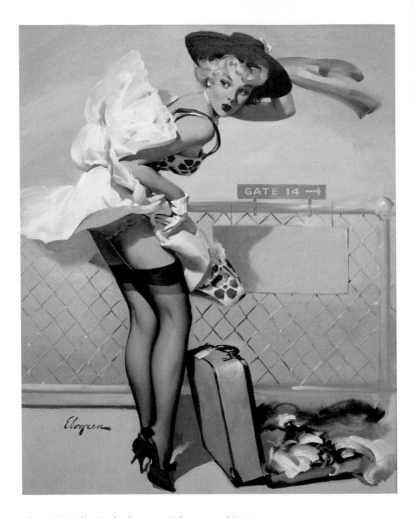

Above: Up in the Air, also known as *Whooooooosh!,* 1965.

Opposite: What a View, 1957.

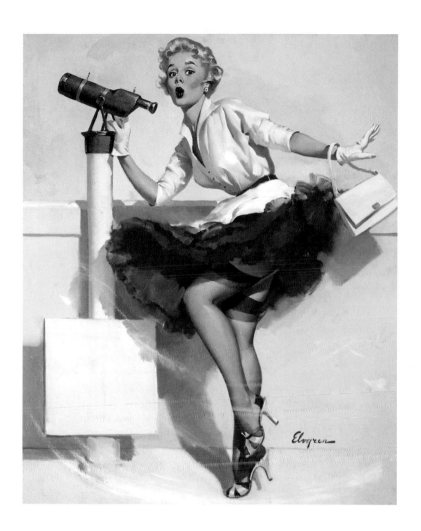

His girls became ever more believable, with increasingly expressive faces and more voluptuous figures.

Above: Reference photo for *A Christmas Eve*, also known as *Waiting For Santa*, opposite, 1954. The model holds packages of Sylvania light bulbs as her "presents," a ready commodity in the studio, given that Elvgren painted the yearly Miss Sylvania pin-up from 1951 through 1960. A fan off-camera molded the gown to the model's legs, providing a ghostly sense of movement.

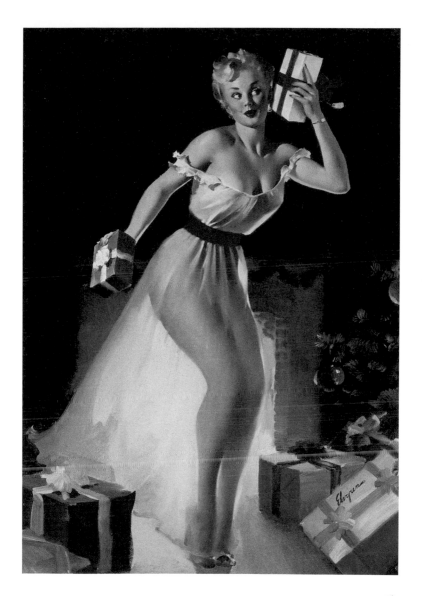

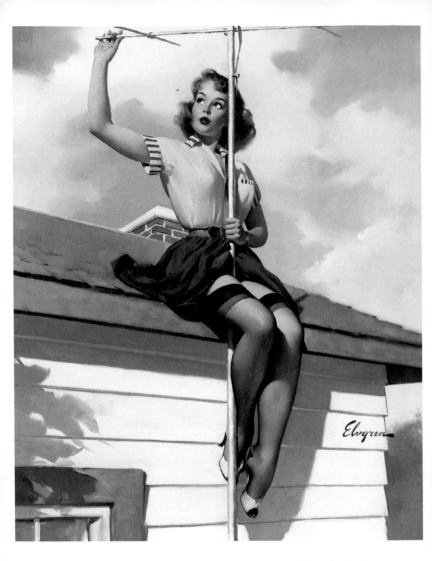

Above: On the House, 1958.

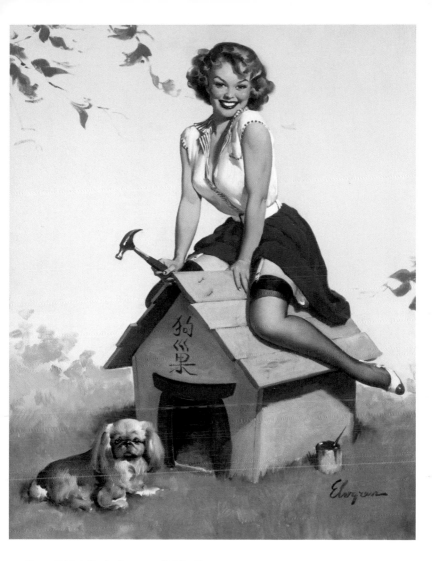

Above: Well Built, also known as *R-R-Roof!*, 1961.

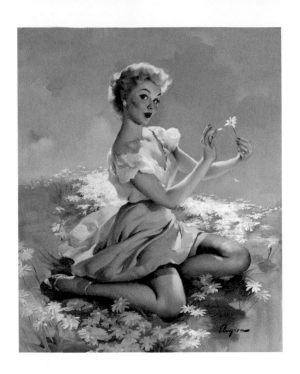

His genius was in maintaining each model's individuality while perfecting her face and figure, yet somehow keeping her attainable.

Above: *Daisies Are Telling*, 1955.

Opposite: *On The Fence*, 1959.

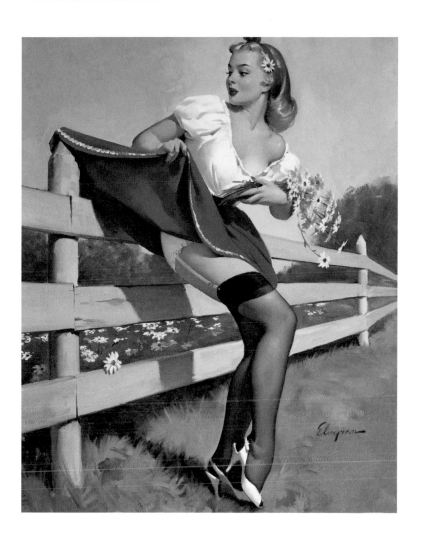

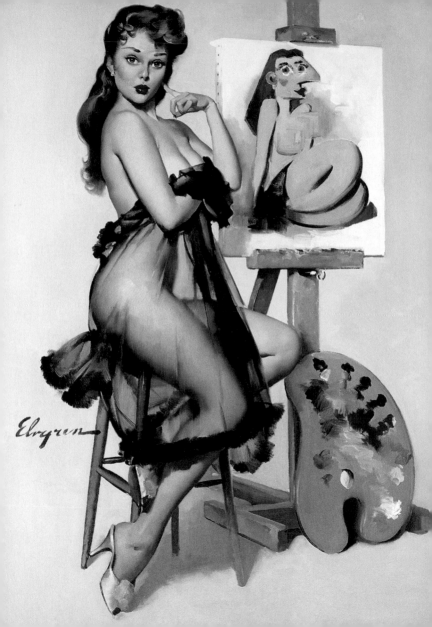

Elvgren

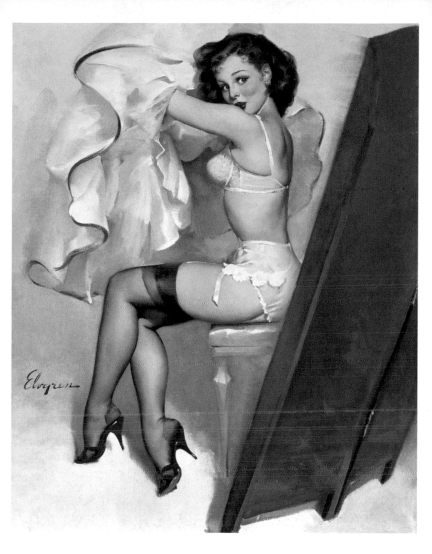

Opposite: Your Choice, also known as Me???, 1962.

Above: Screen Test, 1968.

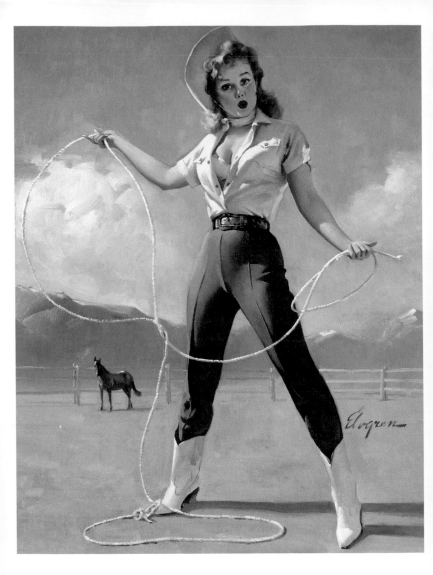

Above: Perfect Form, 1968.

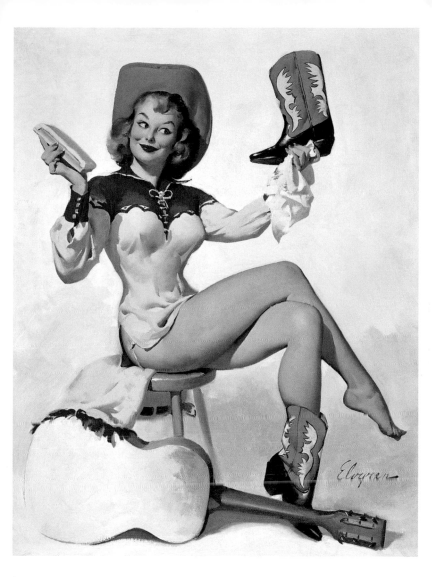

Above: A Polished Performance, 1964.

Sparkling eyes, warm smiles and hourglass figures never go out of fashion, and his girls never look dated.

Above: Elvgren assistant Bobby Toombs, a pin-up artist in his own right, positions favorite Elvgren model Myrna Hansen for the reference photo for *Doggone Good*, also known as *Puppy Love*, 1959.

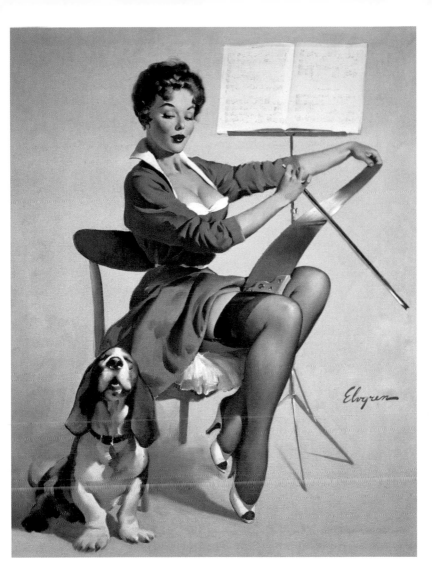

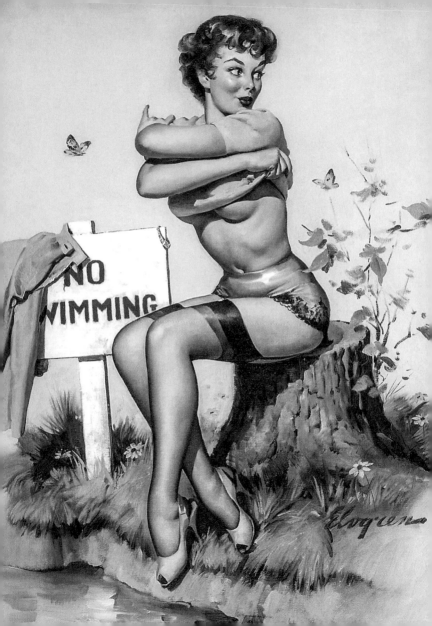

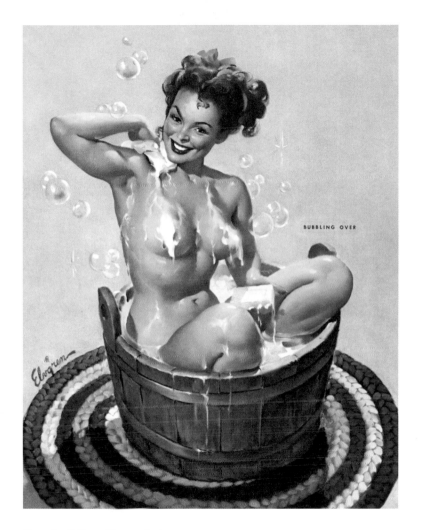

BUBBLING OVER

Opposite: *Taking a Chance*, also known as
No Bikini a Toll, 1962.

Above: *Bubbling Over*, 1951.

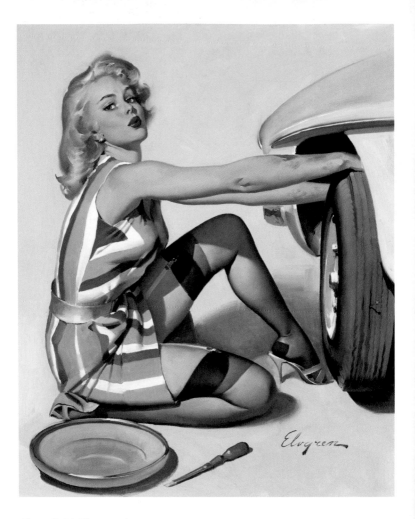

Above: Quick Change, 1967.

Opposite: Let's Eat Out, 1967.

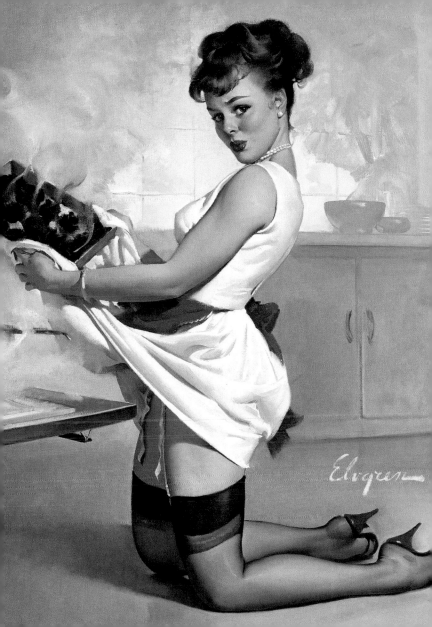

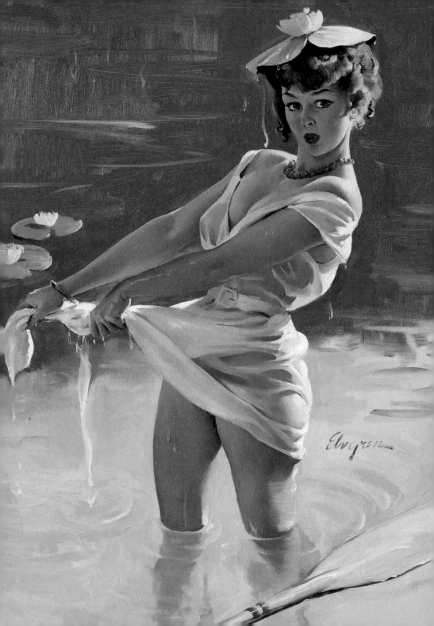

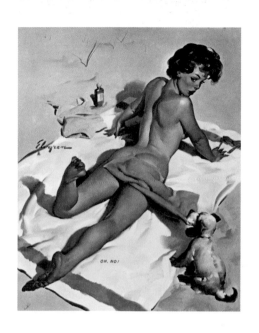

Opposite: Upsetting Upset, 1969.

Above: Oh, No!, 1968, on a duo-fold Dipsy Doodle
promotional give-away. Inside were jokes and cartoons.

He continued producing pin-ups right to the end, leaving an unfinished canvas when he died in 1980, at age 65.

Above: A proofsheet from the model session for the painting *Lucky Dog*, also known as *Dog Gone Robber*, 1958. Elvgren tried two different dogs, and two different dresses on the model, ultimately combining the striped dress worn with the cocker spaniel with the soulful French bulldog.

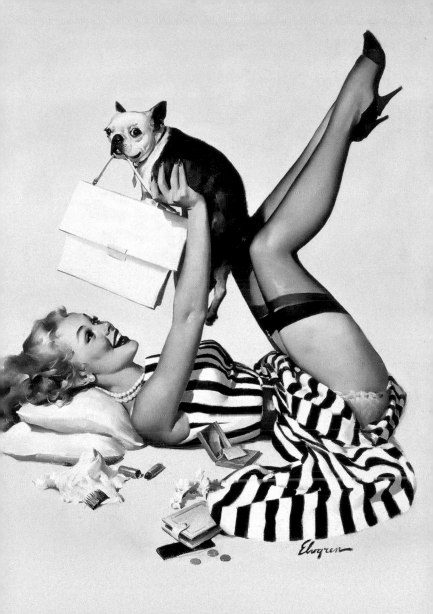

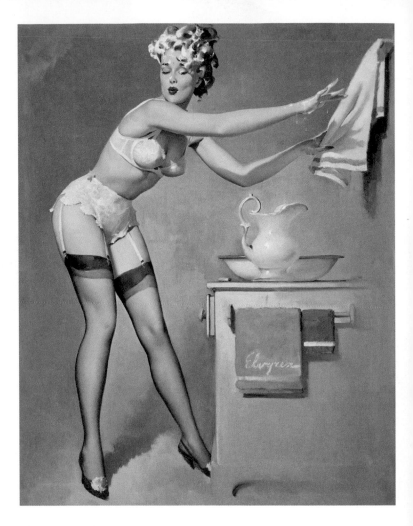

Above: Eye Catcher, 1969.

Opposite: A Refreshing Lift, 1970.

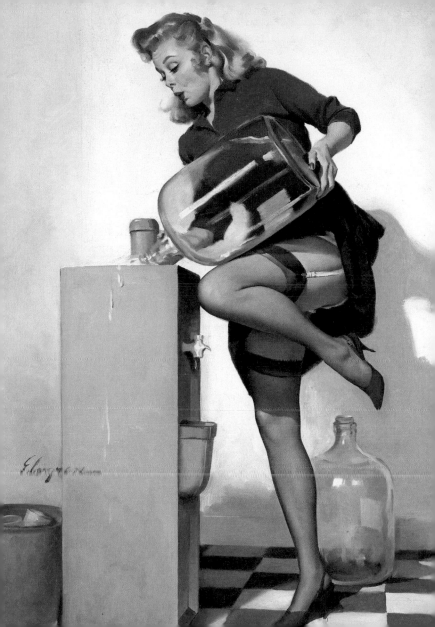

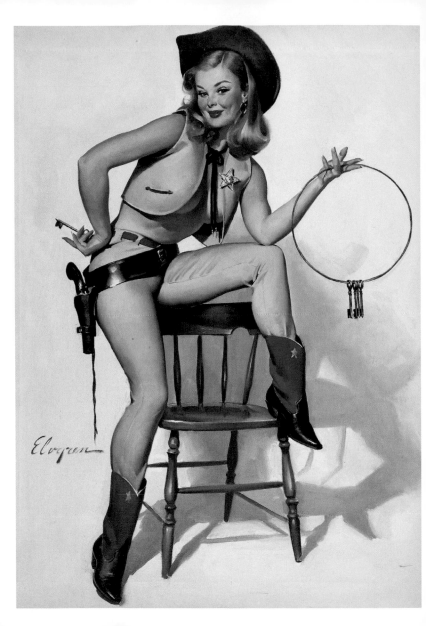

Elvgren

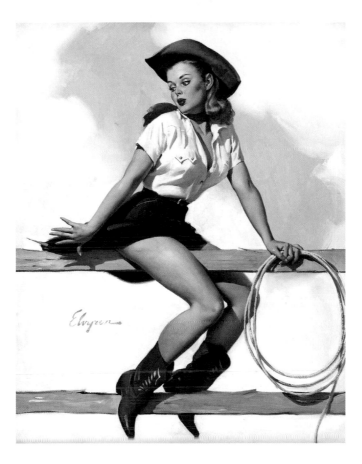

Opposite: *A Key Situatiion*, 1967.

Above: *Hi Ho, Silver*, 1969.

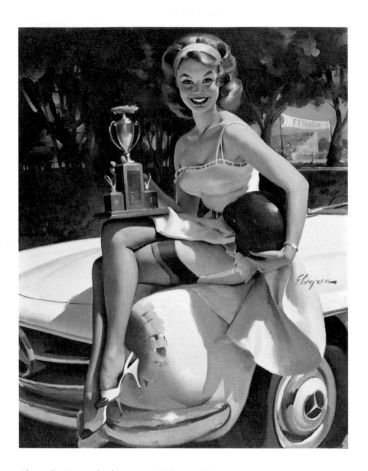

Above: Fast Lass, also known as *A Winner*, 1965.

Opposite: Untitled, circa 1972.

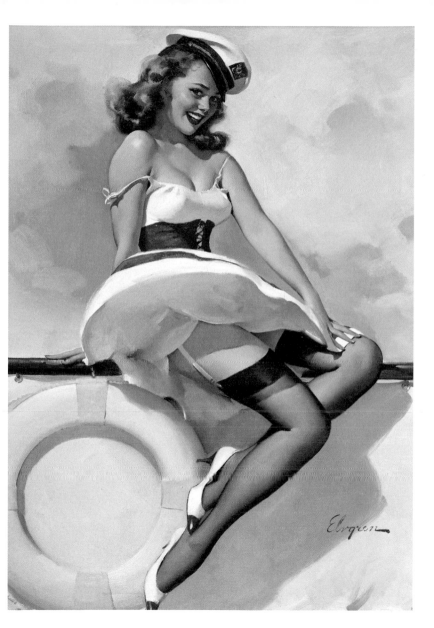

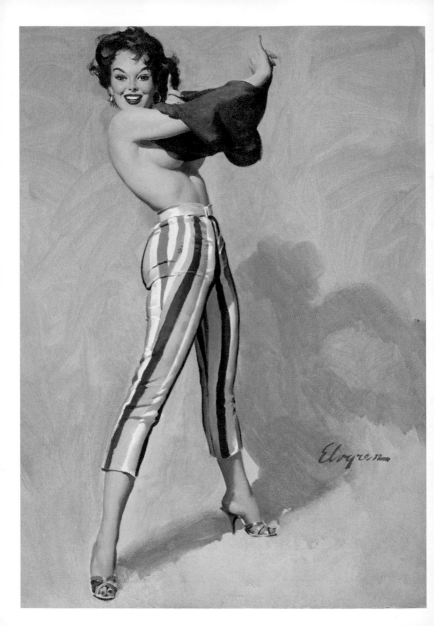

Opposite: Swim, Anyone?, 1969.

Front cover: Bear Facts, 1962.

Endpapers: Your Choice, also known as *Me???*, 1962.

Page 1: Roxanne, 1960.

Back cover: Cee Bee (To Hold), 1951.

Images on the cover, endpapers, pages 1, 2, 8, 9, 10, 11, 12/13, 14, 18, 19, 21, 27, 31, 32/33 and 49 through 192 © Brown & Bigelow. Brown & Bigelow additionally owns the copyright to all Elvgren artworks created after 1944. Images on pages 20, 22/23 and 177 courtesy of Jim Cook. Image on page 77 courtesy of Erwin Flacks. Images on pages 51, right, 80, 81, 86, 89 and 104 courtesy of Grapefruit Moon Gallery, grapefruit-moongallery.com. Images on pages 11, 12/13, 18, 19, 21, 27, 31, 32/33, 35 to 38, 40 to 45, 49, 52, 53, 54, 57, 58, 60 to 63, 66, 70, 71, 73, 75, 78, 84, 85, 87, 88, 92, 94, 98, 101, 102, 106 to 110, 113, 115, 116, 118, 119, 121, 125, 130, 132, 133, 141, 150, 152, 154, 162, 165, 168, 171, 174, 178, 180, 181, 182, 187, 188 and 189 courtesy of Heritage Auctions/HA.com. Images on endpapers and pages 2, 8, 47, 48, 55, 56, 65, 67, 72, 74, 76, 93, 95, 97, 99, 100, 103, 111, 117, 120, 123, 124, 127, 131, 134, 136, 137, 139, 140, 142 to 147, 151, 153, 155, 158, 160, 161, 163, 164, 167, 169, 172, 173, 175, 177, 185, 186, 190, 191 and 192 courtesy of Louis K. Meisel, greatamericanpinup.com. Images on pages 4, 24, 68, 90, 96, 112, 128, 138, 148, 156, 166, 176 and 184 courtesy of Marianne Ohl Phillips, moppinup.com.

EACH AND EVERY TASCHEN BOOK
PLANTS A SEED!

TASCHEN is a carbon neutral publisher.
Each year, we offset our annual carbon
emissions with carbon credits at the
Instituto Terra, a reforestation program in
Minas Gerais, Brazil, founded by Lélia and
Sebastião Salgado. To find out more about
this ecological partnership, please check:
www.taschen.com/zerocarbon

INSPIRATION: UNLIMITED.
CARBON FOOTPRINT: ZERO

To stay informed about TASCHEN and
our upcoming titles, please subscribe to
our free magazine at www.taschen.com/
magazine, follow us on Twitter, Instagram,
and Facebook, or e-mail your questions
to contact@taschen.com.

© 2015 TASCHEN GmbH
Hohenzollernring 53, D-50672 Köln
www.taschen.com

Editor: Dian Hanson, Los Angeles
Art direction: Josh Baker, Los Angeles
Design and layout: Nemuel DePaula,
 Los Angeles
Editorial Coordination: Meike Nießen,
 Cologne
Production: Thomas Grell, Cologne
German translation: Egbert Baqué,
 Berlin
French translation: Cyril Frey, Paris

Printed in Italy
ISBN 978-3-8365-2021-8

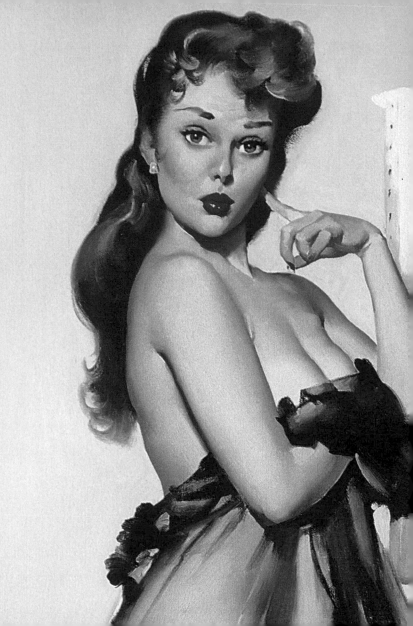